W9-AGM-179

The Complete Oil Painter

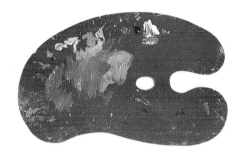

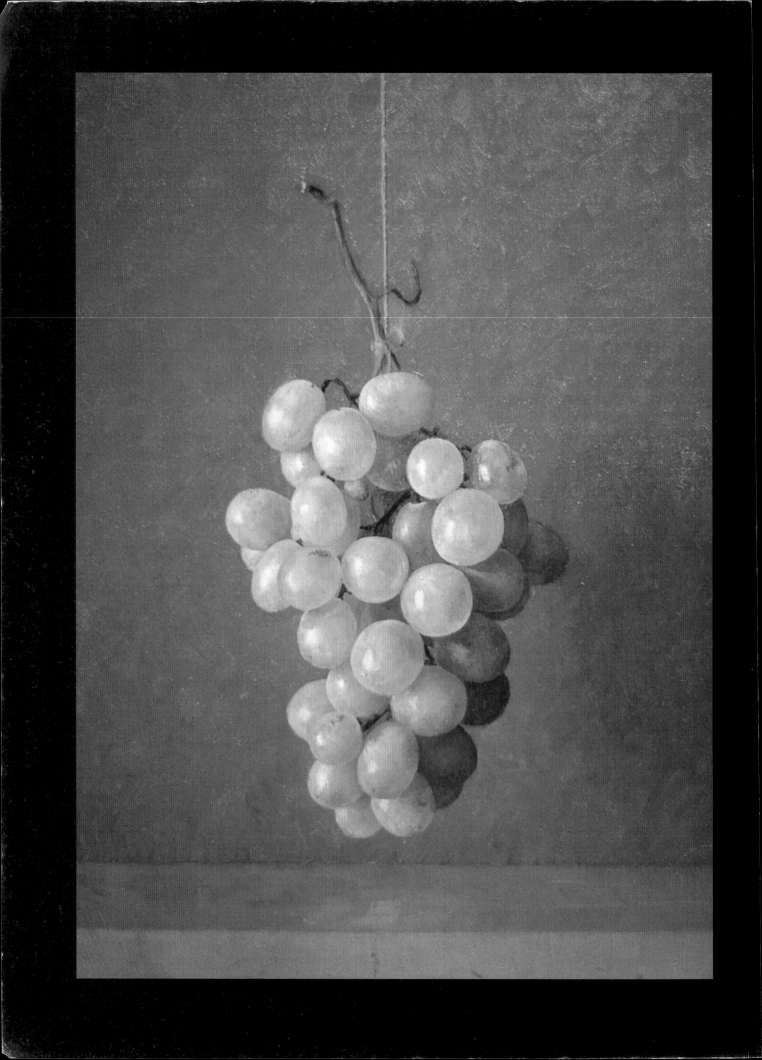

The Complete Oil Painter

the essential reference source for beginning
to professional artists

BRIAN GORST

WATSON GUPTILL • NEW YORK

AUTHOR ACKNOWLEDGMENTS

The author is indebted to the teaching of Wade
Schuman, Jon de Martin, Andrew Conklin, and the
painting faculty of the New York Academy of Art.
Also thanks to Kim Williams and Jeremy Duncan for
their selfless support and advice.

A QUARTO BOOK

Copyright © 2003 Quarto Inc.

First published in 2003 in New York by
Watson-Guptill Publications,
a division of VNU Business Media, Inc.,
770 Broadway
New York, NY 10003
www.watsonguptil.com

Library of Congress Catalog Card No. 2003103063

ISBN: 0-8230-0855-X

All rights reserved. No part of this publication may
be reproduced or used in any form or by any means—
graphic, electronic, or mechanical, including
photography, recording, taping, or information-
storage-and-retrieval systems—without the prior
permission of the copyright holder.

QUAR.OIPA

Conceived, designed, and produced by
Quarto Publishing plc
The Old Brewery
6 Blundell Street
London N7 9BH

Project Editors: Paula Regan, Fiona Robertson
Senior Art Editor: Sally Bond
Editor: Sarah Hoggett
Designer: Tracy Timson
Photographers: Colin Bowling, Paul Forrester,
 Sean Smiles
Illustrator: Sally Bond
Proofreader: Jan Cutler
Indexer: Diana Le Core
Art Director: Moira Clinch
Publisher: Piers Spence

Manufactured by
Universal Graphics Pte Ltd, Singapore

Printed in Singapore
by Star Standard Industries Pte Ltd

9 8 7 6 5 4 3 2 1

Contents

CENTRAL ARKANSAS LIBRARY SYSTEM
SIDNEY S. McMATH BRANCH LIBRARY
LITTLE ROCK, ARKANSAS

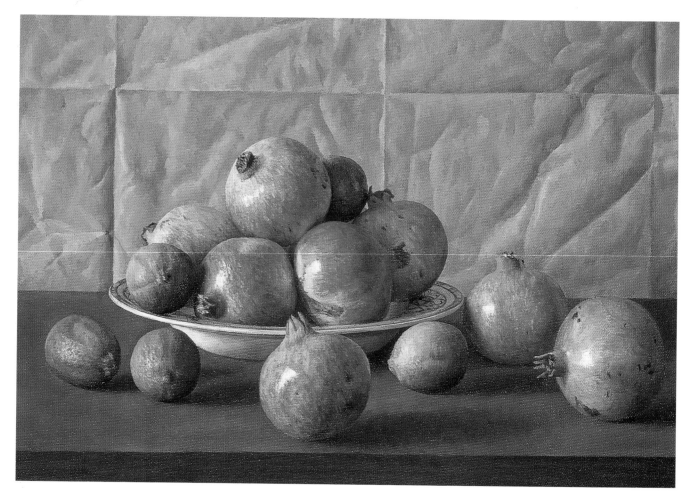

Pomegranates and limes
Brian Gorst
Alkyd on canvas, 1993
24 x 16 in. (61 x 41cm)

Strong color contrasts within a painting need not result in disharmony and lack of picture unity. Here the yellowish hue of the brown paper and the small note of blue in the plate help to temper the relationship between the red and green of the fruit.

Introduction

Compared to watercolor, encaustic, fresco, or tempera, oil paint is a relatively recent medium. It has its origins in northern Europe at the start of the fifteenth century, when drying oils were often added to the egg-yolk medium of tempera, possibly during the later applications of paint. Artists found that by painting in slow-drying oil paint, with its smooth modeling and richness of color, they could achieve greater realism. This, along with the durability of its paint film and the portability of its supports, meant that by the middle of the sixteenth century oil painting had spread throughout Europe to become the medium of choice for most painters. It has since dominated palettes up to the present day, with only the introduction of acrylics during the twentieth century offering any credible alternative to some of the uses of oils.

Today, oil paint is perhaps the medium most closely associated with the practice of painting, and a great many pictures in museums and galleries are painted in oils. It is a sensuous medium that responds uniquely to the physicality and temperament of each artist. Although it is also often

perceived as a "difficult" medium, once you are familiar with its material properties and techniques, you will find oil paint to be user-friendly, forgiving, and capable of almost unlimited revision and reworking.

People who paint in oils are blessed with one of the broadest color and tonal ranges of any medium; moreover, unlike many water- or acrylic-based paints, oils tend not to alter their color or value upon drying. You can achieve richer darks than you can with watercolor while exploiting similar effects of transparency, and the slow drying time of oil paint allows wet-into-wet blending that is far more difficult to achieve with acrylics or egg tempera.

This book is aimed at those with more than a passing interest in the subject of oil painting—leisure painters keen to try a new medium, students pursuing a course of study, or practiced oil painters wishing to diversify or expand their techniques. It covers both observational and non-representational

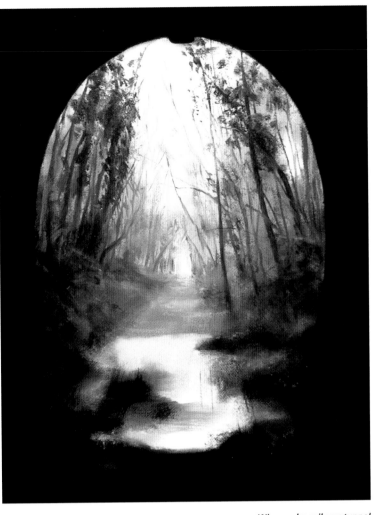

Winscombe railway tunnel
Brian Gorst
Oil on canvas board, 2000
10 x 12 in. (25 x 30cm)

However picturesque a scene may at first appear, painters have always used their "artistic license" to modify further the world around them. Here the trees were rearranged, the colors altered, and the puddles shamelessly shaped to echo the bridge.

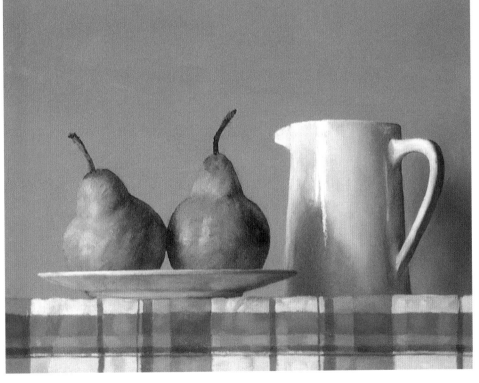

Two pears in a jug
Brian Gorst
Oil on canvas board, 1997
10 x 8 in. (25 x 20cm)

Painted alla prima throughout, this still life composition exploits an unusually low eye level, and clearly demonstrates the potential of oil paint to capture a variety of surfaces within the same picture.

approaches to picture making. The traditional practices of underpainting, glazing, and limited palette techniques are discussed alongside more contemporary trends, such as working on a large scale, abstractly, or with mixed media. Drawing is dealt with only in so far as it can help with composition or in transferring an idea onto the surface to be painted.

The first chapter is a practical reference source regarding tools and materials, while the second chapter aims to help readers to train their eye and develop a more conscious awareness of the aesthetics of painting. Chapter three demonstrates the many different ways of applying oil paint, while chapter four explores both traditional and contemporary approaches to a wide range of popular themes. The final chapter suggests ways in which you can develop your oil painting from a hobby to a vocation.

Good painting is an art, not a science, and cannot be fully learned through any book: it is a combination of skilled craftsmanship, creative bravery, and determined trial and error. *The Complete Oil Painter* is not a recipe book and offers no short cuts—but it will, I hope, introduce you to the delights and potential of working in oils and provide you with a wealth of practical advice that will help you to work in a more efficient, confident, and enjoyable way.

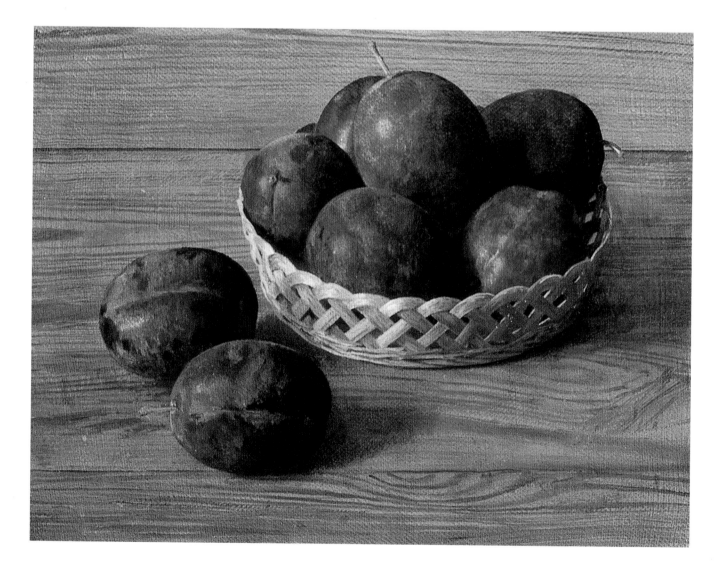

Standing nude at the NYAA
Brian Gorst
Oil on canvas board, 1999
10 x 20 in. (25 x 51cm)

An example of the kind of study
undertaken during an artist's traditional
academic training, this painting
involved an initial measured drawing,
transference onto canvas board,
a colored ground, opaque and
transparent paint applications, and a
separately painted background.

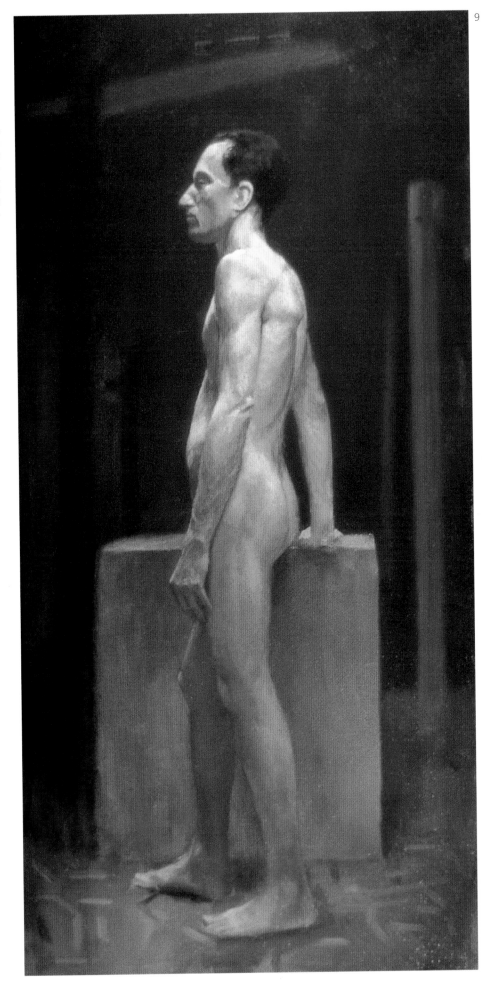

Eight plums
Brian Gorst
Oil on canvas board, 1995
10 x 8 in. (25 x 20cm)

The opaque application of paint that
describes the bloom of the plums, the
oil-rich glaze of the wood grain, and the
wet-into-wet weaves of the basket, were
all unplanned methods of depiction
discovered and honed during the
painting process.

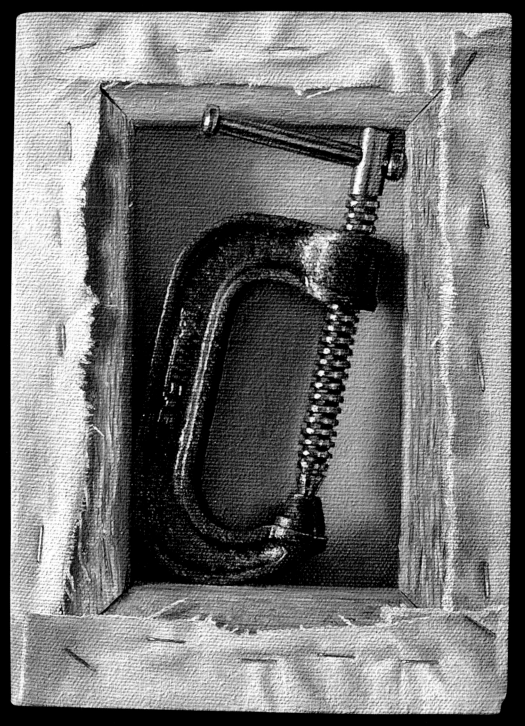

C-Clamp in stretcher
Brian Gorst
Oil on canvas, 1992
8 x 10 in. (20 x 25cm)

Materials and equipment

Artists painting in oils today can consider themselves abundantly provided for when it comes to materials. We have ready access to almost all the pigments used throughout history, brushes in a variety of shapes and sizes, and painting surfaces to suit all types and scales of work. Technological advances in recent years have also provided us with many new and vibrant colors, synthetic brush fibers, and oil-related materials such as alkyds, water-soluble oils, and paint pastels.

To begin working in oils, all you need is a basic understanding of paints and surfaces, and the tools used to manipulate them. Indeed, many of the perceived "difficulties" of oil painting stem from inappropriate use of its tools and materials.

If you are not careful, oil painting can become an expensive activity. This chapter is intended to brief you on the various types of paints, brushes, and surfaces available, and to highlight how to get the most out of any equipment you might already have. A small but carefully chosen range of paints, an inexpensive palette, half a dozen brushes, and a lightweight sketching easel are all you need to work effectively and enjoy the qualities of the medium to the fullest.

MATERIALS 1

Oil paints

Oil paint consists of dry pigment ground in oil. The oil eases the movement of the pigment particles and allows the pigment to adhere to a surface. It also alters the way in which light is reflected and absorbed, and protects the pigment from chemically reacting with other pigments or the atmosphere.

In order for the paints to intermix and dry consistently, the particles have to be evenly dispersed in as little oil as possible. This is best achieved by experienced manufacturers using multiple roll mills, and the vast majority of artists painting in oils today use prepared paints in either tubes or tins, or both. There are many manufacturers worldwide offering oil colors of different qualities and properties. The industry commonly differentiates between students' and artists' quality paints.

Students' quality paints

Students' quality paints offer a varied color range, commonly as part of a starter set, at an affordable price. Standard pigments (sometimes imitations or mixtures) are ground in refined linseed or safflower oil. The paints are designed to have a workable texture with fairly slow, but consistent, drying times throughout the range.

In order to achieve this, and to bulk out the paint to reduce the cost of manufacture, student colors may contain excessive quantities of oil or inert fillers. This can produce colors that do not mix well or tend to yellow, as well as making the paint film less stable, and serious artists will soon find themselves drawn toward more reliable and, in the end, more cost-effective paints.

PAINT PIGMENT DISTRIBUTION

Poorly mixed paints, or those with excess oil, will dry unevenly and slowly.

Even pigment:oil ratio

Poor pigment:oil ratio

Artists' quality paints

Artists' quality paints offer the fullest range of colors with high pigment content. Stiffer in texture and with greater tinting strength than students' quality paints, most brands are suitable for general use. More expensive than students' quality paints, they are divided into different price bands depending on the cost and rarity of the pigments.

Fillers and additives are still used to alter the luminosity, texture, or drying time of some colors, and poppy seed or safflower oil is frequently employed in the paler colors in preference to the darker-drying linseed oil.

Handmade colors

The highest quality and most expensive oil paints are those made by specialist paint producers. Often termed "hand-made oil colors," these paints use only the finest pigments. Sometimes ground in cold-pressed linseed oil, they tend to contain little or no fillers or additives.

You may find that it is more economical and rewarding to accumulate high-quality paints gradually and to mix your own tints and colors from a core of tried-and-tested favorites than to amass a vast range of poor-quality paints that you rarely use.

TUBES AND TINS

While tubes are easily portable, tins are often preferred for larger paintings worked on in the studio. Constant exposure to air, however, can dry the paint in the tin, making large tubes a more economical option.

Alkyds and water-soluble oils

Alkyds are synthetic, resin-based, oil-compatible paints that have shorter drying times than conventional oil paints and produce a sufficiently flexible and strong paint film. They are useful for underpainting and for building up layers and glazes within days, but if alkyds are painted over the top of oils there can be an increased risk of cracking.

Water-soluble oil paints are one of the most recent developments in paint technology, providing a range that can be mixed with specialized oil-rich mediums, using water as a thinner. They are of obvious benefit to people with an intolerance toward the solvents used in conventional oil painting.

Both alkyds and water-soluble oil paints come in smaller color ranges than conventional oils, although accumulating a second set of paint colors may be costly.

UNDERSTANDING LABELS

Labeling can be helpful but also misleading. Watch out for paints called "hue" or "mixture," as these are often inferior pigments masquerading as those of a better quality. Always check the pigment number.

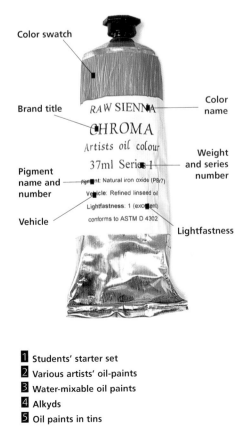

Color swatch

Brand title

RAW SIENNA — Color name

CHROMA

Artists oil colour

37ml Series 1 — Weight and series number

Pigment name and number — Pigment: Natural iron oxide (PBr7)

Vehicle — Vehicle: Refined linseed oil

Lightfastness: 1 (excellent)

conforms to ASTM D 4302

Lightfastness

In oil paint production, machine-operated mills are used by paint manufacturers to grind large quantities of pigment into oil to make paint.

1 Students' starter set
2 Various artists' oil-paints
3 Water-mixable oil paints
4 Alkyds
5 Oil paints in tins

MATERIALS 2 Pigments

Pigments may be derived from inorganic sources, such as minerals and metal oxides, or from organic sources, such as plant and animal substances. Nowadays there are also many synthetic versions that equal, or even improve on, most of the characteristics of the natural source. There are several aspects of pigments that you need to think about as an artist. Tube labels and manufacturers' color charts will give you a certain amount of information, and first-hand experience of using oil paints will provide the rest.

TRANSPARENCY/OPACITY

Depending on the size and nature of its pigment particles, a paint mixture may be transparent and allow light to pass through it or it may be opaque and absorb and reflect light. Most manufacturers indicate whether particular paints are transparent, semitransparent, or opaque.

TINTING STRENGTH

The tinting strength is the extent to which a color maintains its intensity when it is mixed with white. This information is rarely displayed on tubes and varies for each brand and grade of paint. Some pigments may be less intense in color when mixed with white, but still maintain a strong hue when diluted with a medium.

TEXTURE AND MIXABILITY

Oil paints can be buttery, stiff/short, stringy, oily, rough/grainy, or smooth. These characteristics can be altered through oil control. Often the highest-quality paints offer the broadest range of textures.

DRYING TIME

The drying time is not usually printed on paint labels. Different pigments have different drying times; in addition, manufacturers add drying agents to slower-drying pigments to give their range a more consistent drying time. Some oil paints can be touch-dry in hours, others can take a week (depending also on thickness of paint, dilution, and ground absorbancy). It is useful to note which colors are driest on your palette at the end of each painting session.

LIGHTFASTNESS

Lightfastness is the ability of a ground pigment to retain its appearance after prolonged exposure to light. Lightfastness is often given on tubes and color charts as an ASTM (American Society of Testing and Materials) rating, with I being excellent, II very good, and III insufficient for artistic use. However, some manufacturers have their own rating system and do not use the ASTM notation.

The following list sets out the most commonly used pigments and their color index name (a code that is unique to each pigment and which should be present on all paint labels). Unless otherwise indicated, pigments are lightfast and have an average drying time.

SWATCHES EXPLAINED

Toptone is the paint's solid appearance when applied thickly. Undertone is its transparent appearance when thinned with a medium or painted on a light ground. Tint is the color of the paint as it appears when mixed with white.

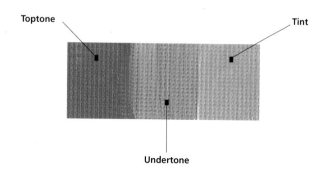

Toptone

Tint

Undertone

WHITES

Flake White (PW1), also called Cremnitz or Lead White, may be the earliest manufactured mineral pigment. It forms a reliable, opaque, and flexible paint film. It is excellent for underpainting as it dries fairly quickly and produces tints that do not differ too greatly from their original color. Flake White is now supplied in tins rather than tubes because it contains lead.

Titanium White (PW6) has only been in use since the early twentieth century. It is a smooth-textured, pure white with an opacity that is useful for solid surfaces and highlights but tends to cool down tints. Its slow drying time makes it ideal for alla prima or plein-air painting.

Zinc White (PW4) is a semitransparent, cool white that can be a useful addition to the palette when milky glazes or subtle overpainting are required (for example, in depictions of water, glass, or thin fabric). Zinc White has a reputation for drying to a less flexible paint film than the other whites, which can cause cracking.

You will also find combinations called Foundation White, Underpainting White, Opaque White, Transparent White, and Flake White Replacement. These are mixtures of titanium and zinc in differing proportions.

YELLOWS

1 Yellow Ocher (PY43) is a muted, traditional earth color that is ideal in a limited palette (see Earth palettes, page 41). Yellow Ocher mixes well. It is semi-opaque, yet it can reveal rich undertones in the highest-quality grades. It is often replaced by Mars Yellow (PY42), which is slightly more intense and fractionally warmer.

2 Raw Sienna (PBr7) is a reasonably quick-drying earth yellow with a faint bias toward orange. It is darker in toptone than Yellow Ocher but has greater transparency.

3 Lemon Yellow is a generic name for green-biased yellow pigments that give an intense opaque or semitransparent color. They are usually slow drying. Often derived from Cadmium (PY35), but Cadmium Barium (PY35:1) and Hansa (PY3) are cheaper alternatives.

4 Cadmium Yellows (PY35, PY37) are an intense, opaque, slow-drying family of pigments possessing good tinting strength with rich undertones. They are available as Light, Medium, and Deep, with biases toward green or orange. The Cadmium Yellows can be expensive colors, but they have come to replace the fugitive Chrome Yellows (PY34).

5 Hansa Yellows (PY3, 65, 73, 75, 98), also called Arylide Yellows, are a family of yellows with good tinting strengths and brightness, with a medium-to-slow drying time.

6 Naples Yellow (PY41) is a traditional, very pale yellow pigment that is useful in color mixing with earth colors and in flesh tones. It is commonly replicated by mixtures of yellow and white.

ORANGES

7 Mars Orange (PY42) and Mars Brown (PBr6) are semi-opaque, muted brown-oranges with moderate tinting strengths. They are quicker drying than the more intense colors.

8 Cadmium Orange (PO20) is opaque, bright, and intense, with a very slow drying time. It is available in redder and yellower hues. Tubes of genuine cadmiums feel heavier than imitations.

9 Perinone Orange (PO43) is a transparent orange with a full, intense color. Benzimidazolone Orange (PO62, PO36) is a semitransparent color of equal intensity. Often marketed under different tube names, they dry quicker than the cadmiums.

REDS

10 Indian Red (PR101) is a muted red with a violet bias that is useful in limited palettes. Indian Red is one of the family of synthetic iron oxides. It is semi-opaque, with a rich undertone that cools significantly when it is mixed with white.

11 Light Red Oxide (PR101), sometimes called English Red, is another variation on the synthetic iron oxides. The exact name and hue varies between manufacturers, but they are all reliable semi-opaque pigments in the muted red-orange range.

12 Cadmium Reds (PR108) Available as Light, Medium, and Deep, these intense, opaque colors mix well, providing a strong, flexible, slow-drying paint film. The red-orange shades have come to replace the less reliable Vermilion (PR106). Cadmium-Barium Red (PR108:1) provides a less expensive, if slightly weaker, alternative.

13 Quinacridone Magenta (PR122) and Quinacridone Red (PV19) are intense, transparent, and economical pigments, with good tinting strengths, that have come to replace such traditional but less lightfast colors as Crimson Lake and Rose Madder.

14 Alizarin Crimson (PR83:1) is a slow-drying, transparent red-violet that mixes well with blues to make clear purples. There are doubts as to its lightfastness.

15 Perylene Reds (PR149) and *Napthol Reds (PR9, PR112) are all semitransparent with intense, bright toptones. They can be biased toward red-orange or red-violet.

VIOLETS

16 Cobalt Violet (PV14) is semitransparent and available in two shades. Its fast drying time and mild tinting strength make it ideal for use with earth colors.

17 Manganese Violet (PV16), also called Mineral Violet, is quick drying and more opaque and pure than Cobalt Violet.

18 Dioxazine Violet (PV23) is an intense, transparent, pure violet with a very high tinting strength. The smallest tube will last a lifetime.

BLUES

19 French Ultramarine (PB29) is a transparent blue-violet with a rich, intense undertone and good tinting strength. This fairly slow drier is a useful color mixer.

20 Cobalt Blue (PB28) is a semitransparent and relatively quick drying blue, with an enigmatic undertone that justifies its high cost.

21 Cerulean Blue (PB35) is a blue-green, opaque pigment that can display good undertones. It mixes well to make strong greens.

22 Manganese Blue (PB33) is similar to Cerulean Blue in hue, but has greater transparency and a greener undertone. It is sometimes replaced with Phthalo Blue.

23 Phthalo Blues (PB15) are a highly intense, transparent range of blues with high tinting strength. Phthalo Blues can sometimes be difficult to control as they tend to dominate mixtures.

24 Prussian Blue (PB27) is one of the fastest drying paints. This intense blue-green pigment has a dark, metallically tinged toptone with a rich, glowing undertone. It is a good but dominant mixer.

GREENS

25 Oxide of Chromium (PG17) is an opaque, reliable, slightly muted green with good tinting strength. Excellent as part of an earth palette, it is used to replace or bulk out the weaker Terre Verte (PG23).

26 Viridian (PG18) has a dark toptone but an intense, vivid, cool-green undertone, making it an ideal transparent glazing color with good tinting strength.

27 Phthalo Green (PG7) and *Phthalo Green Yellow Shade (PG36) are both reliable and transparent shades with very intense and dominant tinting strengths. They are used by manufacturers in place of other greens such as Emerald Green, Chrome Green, and the fugitive Sap Green.

BROWNS

28 Burnt Umber (PBr7) is an excellent traditional, semitransparent, warm brown with a rich, dark toptone. Its quick drying time makes it ideal for use in underpainting and imprimatura.

29 Raw Umber (PBr7) is a semi-opaque, dark brown pigment with a cool yellow-green hue that can be useful in earth palettes and landscape painting. It dries fast, which makes it a useful color to apply unmixed in the early layers of a painting.

30 Burnt Sienna (PBr7) has a brown-earth toptone that reveals glowing muted orange hues in glazes and mixes. Burnt Sienna is a reliable, inexpensive pigment with a fairly quick drying time.

31 Venetian Red (PR101) and *Mars Red (PR101) are members of the synthetic iron oxide family. Both produce solid brick-brown colors with good all-round properties.

32 Transparent Red Oxide (PR101) is a darker and more transparent version of the other iron oxides, perhaps a little more intense than Burnt Umber.

BLACKS

33 Ivory Black (PBk9), also called Bone Black, is now made exclusively from charred animal bones rather than from ivory. It is a good economical color, with a dark brown undertone and a very slow drying time. Ivory Black is available mixed with Ultramarine as Blue Black.

34 Lamp Black (PBk6) The very first pigment used by man, Lamp Black is an opaque, smooth black with a subtle, bluish undertone. A very slow-drying pigment, it can be useful in paintings made using a limited palette of earth colors.

35 Mars Black (PBk11) A dense, opaque black with a neutral-to-brown hue. An average drying time makes Mars Black a good choice for grisaille painting (see Tonal palettes, page 40).

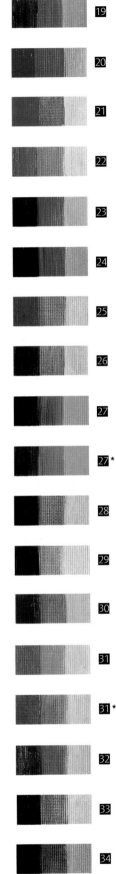

MATERIALS 3

Mediums

Medium is the term for the fluid that surrounds the pigment and facilitates its application onto a surface. In the case of oil paints, the medium consists principally of the binder and the thinner and, to a lesser extent, of additives such as varnishes, resins, drying agents, retardants, and textural materials.

Binders

The binder is the most important element in the medium as this is what adheres to the painting surface, holding the particles of pigment within it and drying to form the paint film. Oil paints by definition have a drying oil as the binder and the tubes of paint that we buy contain the pigment already ground in just enough binder to secure its storage and ease its transfer onto the palette. You need to add further oil binder, within a medium, to the paints on the palette to make them workable with a brush.

Linseed oil is the most commonly used drying oil. It is obtained through different processes from the seeds of the flax plant. ("Lin" in linseed has the same derivation as it does in linen, the cloth made from flax.)

1 Raw linseed oil is dark yellow in color. It is obtained by pressing steam-heated flax, but is used only as a medium for some industrial paints.

2 Refined linseed oil has been in use since the eighteenth century and is refined by temporarily mixing the hot-pressed oil with sulphuric acid and water. A good economical oil of varying light-to-golden color, refined linseed oil is the standard binder in most tubed paints. The paler refined linseed oils do not necessarily dry lighter than those of a straw-colored hue.

3 Cold-pressed linseed oil is probably the finest and most traditional of the linseed oils, and it is still used to grind some of the highest-quality oil colors. It has excellent handling and dries faster than refined oil, forming a strong, secure paint film. However, its high cost can make it uneconomical for larger-scale or more experimental work.

4 Stand oil is a thick, syrupy oil made by polymerizing linseed oil through sustained heating. It can be diluted into a pale and fairly slow-drying medium that has good glazing and handling potential and little tendency toward yellowing. Used in larger quantities or with linseed oil, stand oil has good leveling properties, which leave an enamel-like film when painted on a smooth surface, such as wood panel or copper.

5 Sun-bleached linseed oil is used mainly as a glazing medium because of its fast drying time and pale color. It can be of use in paintings with very pale colors.

6 Walnut oil dries faster than poppy oil but has little advantage over linseed oil.

7 Poppy oil is pressed from poppy seeds. It is very pale, thin, and almost odorless, and has a buttery consistency within paint. Its long drying time can be of use in sustained wet-into-wet painting. Poppy oil may be prone to cracking with age.

Safflower oil is increasingly used by manufacturers and gives paint a buttery texture. Its long-term effects on the paint film have yet to be ascertained.

Thinners

If paint is diluted with oil alone it may wrinkle, become yellow, or take too long to dry—and so a thinner is mixed with the binder in the medium to help aid the flow of the paint. The thinner does not remain in the paint film but evaporates from the surface. The solvent nature of the thinner is sometimes useful to "cut" through wet or drying paint to return to the ground during underpainting.

Too much thinner in the medium, however, can leave the pigment poorly protected and the paint film weak and prone to cracking. The ratio of binder to thinner depends on many factors: the absorbency of the surface and pigments; the extent to which you want to manipulate the paint; the amount of glazing, layering, or reworking needed in the painting; and the quality of the paints.

1 Distilled turpentine, the distilled resin of pine trees, has been the standard companion of linseed oil in painters' mediums for centuries. Its purity means that it evaporates fully from the painted surface at an agreeable rate, without leaving any residue. It can be expensive to use in large quantities and so should not be used for cleaning brushes. Its strong odor can be unpleasant, especially in unventilated areas, but you can minimize this by storing it in small containers and dippers with narrow openings. Contact with the skin should be avoided.

2 Artists' mineral (white) spirit is a petroleum product sharing many properties with turpentine. A good-quality mineral spirit can be used in place of distilled turpentine as a cost-effective thinner, particularly in larger works and in underpainting. However, it is not as strong a solvent, and can leave the paint surface matte.

3 Odorless thinners and thinners such as the orange-smelling sansador have become more popular in the wake of tighter health-and-safety laws and consumer demand. They should be used in the same way as artists' mineral spirit.

4 Household mineral (white) spirit/turpentine substitute can be used for some modern, large-scale painting procedures, but it is not generally suitable for painting because it leaves a residue. It is best restricted for use in cleaning brushes and other equipment.

Additives

Although a simple mixture of linseed oil and turpentine serves most needs, throughout history painters have added substances to their medium in order to modify its behavior. Resinous varnishes are traditionally used to alter the finish, transparency, or handling of the paint. Other additives can directly affect the drying time, the matteness, or the texture of the paint. Remember that an overcomplicated medium may negatively affect the structural integrity of the paint film.

1 Venice turpentine is a resin balsam from the larch tree and is said to have been used by Rubens. It is commonly added to glazing mediums and increases the gloss of the paint. It can retard the drying rate of the medium.

2 Damar varnish is a clear resin dissolved in turpentine that can increase the transparency of glazing mediums. As it is one of the main components in protective varnishes, it should be used in only small amounts in a glazing medium, otherwise the glaze may be accidentally removed when the painting is cleaned.

3 Stand oil see entry opposite.

4 Oil of spike lavender should not be confused with the perfume: this oil is distilled from the broad-leafed spike variety of lavender. It can be used as an alternative to turpentine (useful for people with an allergy to turpentine), but it is more expensive and slower drying.

5 Oil of cloves placed on a fresh blob of oil paint will retard its drying time considerably—a few drops will suffice. This is a useful way of preserving a complex color mixture on the palette, but overuse may affect the structure of the paint layer.

6 Liquin is a useful and well-proven alkyd resin that can be mixed with the medium in generous quantities to shorten the drying time significantly. It is excellent in glazes, improves the flow of the paint, and increases the flexibility of the paint film. It may not always mix quite as easily with oil tube colors as other varnish mediums.

7 Pure beeswax can be mixed with warm turpentine or applied ready-made as a premixed, cold-wax medium. It produces a matte finish and can increase the thickness of the paint. Pure beeswax is useful in modern, abstract techniques where illusionistic effects are less important.

8 Textural substances, such as gels, beeswax, sand, and sawdust, are often added to the paint. Some gels aid the thickness and drying time of the medium in order to achieve impasto effects. Other additives are used simply to give physical mass. Textured paint, which is used in many abstract and mixed media approaches, is usually applied with a palette knife.

MATERIALS 4 # Supports

The support on which you paint your picture must be able to take a ground or size and to remain flat, without warping, shrinking, or deteriorating over time.

Stretched canvas

The most widely used support for oil paintings over the last 400 years has been the stretched canvas. Its popularity is down to the ease with which a canvas of any size can be manoeuvred and the cost-effectiveness of the materials. (The term "canvas" is used to describe the fabric, the stretched support, and the finished piece of art itself.)

Many artists find that the springy nature of stretched canvas adds an extra subtlety to their touch and its texture can transform paint strokes into scumbles of broken color (see page 64). Canvases are, however, vulnerable to damage from the front and back and, if not properly prepared before painting, the fibers of the canvas can be corroded by the oil paint. (See Sizing a canvas, page 114.)

Canvas is available in a number of different weights—portrait and fine grain, medium grain, and coarse or heavy grain. It can be bought by the yard, both primed and unprimed, and is commonly sold ready stretched on standard-format stretcher bars. Stretcher bars have to be made of seasoned timber so that they do not warp or twist. They are sold in pairs and larger-sized stretchers have one or more crossbeams. (See Stretcher bars, page 112, and Stretching a canvas, page 113.)

Cotton and linen canvas

1 Linen is the more expensive of the two, but it has some advantages over cotton. The fibers of the flax plant, from which linen is made, are considerably longer than cotton fibers, forming a fabric with greater strength that is less likely to stretch and sag over time. Natural oils in linen also prevent it from becoming brittle in the way that cotton fiber is prone to do. All-linen canvas is gray-brown in color. (If enough size is applied, this color can create an interesting painting surface without the need for a ground.)

2 Cotton is less expensive than linen and so has become the most popular canvas fabric. Cotton Duck is the canvas of choice for most manufacturers of ready-made stretchers. The weave of the cotton has a more mechanical feel to it than linen, and it is also a little less naturally receptive to applications of grounds.

The pale, straw color of cotton gives a bright and uniform surface that can be pleasing to paint upon if sized but unprimed, and despite its possible long-term weaknesses, cotton is a surface that is suitable for most general needs.

3 Flax can refer to the heaviest coarse linen. Once favored by the great sixteenth-century Venetian artists, Titian and Veronese, flax is today limited in use mainly to some large or textured abstract works. The sacking material called jute is also used in this way. Both flax and jute must be securely sized to protect their loose weaves.

4 Calico is a type of cotton fabric; it is lighter than most cotton used for canvases. It can be a pleasant surface to paint on when it is sized and it is strong enough for small-scale work.

Rigid supports

Panels and boards made from natural or processed wood provide solid surfaces to paint upon and the smooth surface can be of use to those striving for detail. These supports are ideal for smaller works. Larger sizes of wood or board may need batoning or cradles attached to maintain their flatness, and this can make them inordinately heavy compared to stretched canvases. (See Preparing boards and panels, page 115.)

1 Wooden panels predate canvas, and the eternal smile of the *Mona Lisa* attests to their permanence and suitability as a support. Oak, poplar, and mahogany have all been used by artists, although the complex techniques involved in seasoning, cradling, and gessoing the wood mean that most panels were prepared by specialists. Prepared wooden panels are still available, providing a smooth, secure surface; and antique furniture is probably the best source of seasoned, untreated, wood.

Plywood is made up of thin sheets of wood bonded with alternating directions of grain, making a strong panel that (in the higher qualities) is less susceptible to warping than wood. Its suitability for painting depends on its quality of manufacture, its age (the older the better), and the smoothness of its outer panel. Plywood is a lighter alternative to wood panel.

2 Masonite (also known as hardboard) is a thin panel made of compressed wood pulp. It is very useful for small painted studies and miniatures. It is better to paint on the flat, shiny side than on the embossed, woven reverse, which can tend to dominate any picture painted upon it. Masonite can be cut with a knife, making it convenient for those without the space or tools for sawing. It is prone to warping after priming, but this can be controlled by painting an "X" from corner to corner on the reverse, which cancels out the effect by making the board warp both ways.

3 Medium-density fiberboard (MDF) is probably the most efficient of all the boards and panels. It has a smooth surface and is moderately priced, with a proven ability to remain very flat and rigid over time. Although there is little need for batons, MDF panels can be quite heavy and so the thinner ¼-in. (6mm) and ⅜-in. (1cm) thicknesses are recommended for artistic use. Care should be taken when sawing MDF (see Health and safety, page 123).

4 Mass-produced canvas boards combine the texture of canvas with the convenience of boards, and their low cost and ready availability in art stores make them popular. Lightweight and thin, they are convenient for sketching out of doors and student work. However, the cardboard underneath the low-quality cotton fabric can absorb moisture, causing warping and loss of rigidity.

5 Covered panels are, as the name suggests, Masonite or MDF panels covered with calico or off-cuts of canvas. Inexpensive to make, they overcome many of the drawbacks of canvas panels.

6 Metal is particularly compatible with oils. Copper, zinc, and aluminum are all recommended surfaces, as they are extremely rigid and smooth, making them particularly suitable for highly detailed work. The cost and weight can be prohibitive for large-scale work, but sheet metal is the only support that does not need an application of size or ground before painting.

7 Paper and card can be used for oil paint, but they must be protected from the paint layer with size and ground or an acrylic-based primer. You can do this yourself or buy pads of ready-primed paper. Finished paintings on paper can be glued on to boards and framed as panels.

8 Some plastics are now used to make drafting film, which is rather like tracing paper. This is a pleasant, smooth surface for sketching in oil that is inert to the corrosive action of the linseed oil.

MATERIALS 5 Grounds

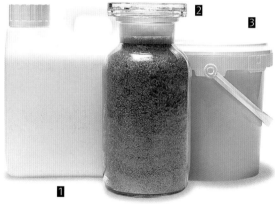

The ground or "priming" is an impervious layer that separates the support from subsequent paint applications. A ground strengthens and evens out the canvas texture and provides a luminous or colorful base on which to paint. "Ground" refers to the dried surface, while "primer" most often refers to the liquid paint that achieves this; the two terms are used in close conjunction and are almost interchangeable.

Grounds can be oil based or acrylic based and both are suitable for oil painting. Lead White is the pigment traditionally used in oil-based grounds, but Titanium White is more commonly used for commercially prepared oil and acrylic grounds and ready-primed canvases. Alkyd-based ground is also available, and should be used in the same way as oil-based ground in all but drying time. (For the use of colored grounds, see page 117.)

Sizing canvas

When you use stretched canvas, you must apply a coat of size before you apply the oil ground. This prevents the oil from both the ground and the painting corroding and rotting the fibers of the canvas. The size layer must have a neutral pH value. It must also be thin enough to penetrate the canvas weave without flowing through it and be at least as flexible as the paint film.

Rabbit-skin glue is the size traditionally used in oil painting. Although preparing and applying this size can take practice, it provides a cost-effective and proven barrier between paint and support (see Sizing a canvas, page 114). Acrylic size is simpler to use but it is more expensive and does not have such a proven track record of compatibility with oils. PVA or white glue should never be used as a size on canvas as it can become very brittle and unstable over time.

SIZES
1. Acrylic size
2. Rabbit-skin glue granules
3. Ready prepared rabbit-skin glue

PRIMERS
4. Acrylic gesso
5. Acrylic primer
6. Gesso
7. Oil primers

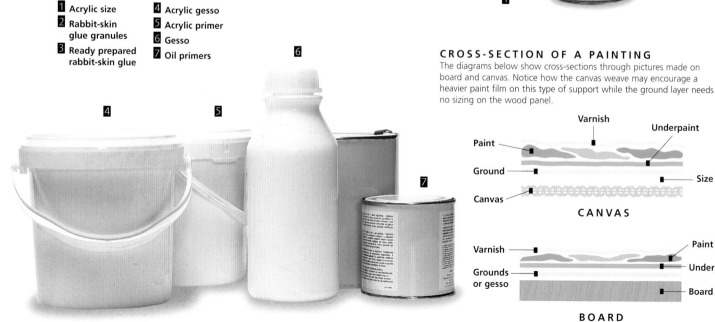

CROSS-SECTION OF A PAINTING
The diagrams below show cross-sections through pictures made on board and canvas. Notice how the canvas weave may encourage a heavier paint film on this type of support while the ground layer needs no sizing on the wood panel.

Varnish
Paint
Ground
Canvas
Underpaint
Size

CANVAS

Varnish
Grounds or gesso
Paint
Underpaint
Board

BOARD

Priming canvas

Oil ground should be applied as a single, solid coat, using a wide, stiff brush or a large palette knife to drive the primer into the weave (see Priming, page 116). Freshly oil-primed canvases need to dry for around three months before use, which is perhaps their greatest drawback, but they provide the most reliable surface to paint upon. An oil ground allows the paint to move freely across the surface and to adhere well to it when it is dry, while at the same time preventing the surface from absorbing excessive amounts of oil from the paint.

An acrylic ground creates a flexible barrier between the paint layer and the canvas without having any adverse effect on the canvas fibers. This means that it can be used without a size layer. (An acrylic size may help an acrylic ground to adhere to linen canvases, but an acrylic ground does not adhere well to rabbit-skin glue.)

Acrylic grounds dry in no more than a day, but the surface that is produced is not ideal for oils. It can at times be too absorbent and contribute to "sinking" in areas; at other times, the surface may be too shiny and repel the paints. Acrylic grounds are not as consistently reliable as oil-primed grounds and the artist should therefore monitor the use of oil in the medium.

Acrylic grounds are sold as "acrylic primer" and "acrylic gesso." The two products are very similar, although acrylic primer tends to be less absorbent and less matte than acrylic gesso. True gesso, traditionally employed as a ground for tempera, is too inflexible to be used in priming canvases.

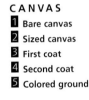

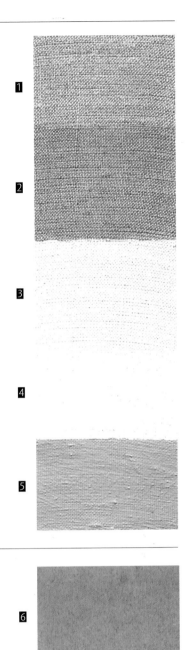

CANVAS
1 Bare canvas
2 Sized canvas
3 First coat
4 Second coat
5 Colored ground

Priming rigid supports

Most wooden supports need to be sanded until smooth, whereas Masonite needs to be sanded to roughen its shiny surface. Acrylic primer is especially suited to the priming of wood and board panels and is best applied in a series of decreasingly diluted coats with a good-quality, soft, decorating brush, according to the manufacturer's guidelines.

True gesso ground (a combination of glue size and white filler) has a long tradition of use, particularly with tempera and gilding techniques, but it is too absorbent for most underpainting techniques in oil.

Oil primer can also be used on rigid supports, with varying degrees of success, and a size layer is recommended to prevent overabsorption of the oil content. An alkyd-based size is a faster-drying alternative to oil, producing a satisfactorily absorbent surface on rigid supports. The use of PVA or white glue as a size on rigid supports is not recommended as it has a tendency to trap air bubbles, discolor, and become brittle over time.

WOODEN SUPPORT
6 Bare wood
7 Primed first coat
8 Primed second coat

EQUIPMENT 1 # Brushes

It is through the narrow length of a paintbrush that the sensitivity, expression, and perception of the artist must travel. The choice of brush will affect the style and finish of the painting, as well as the speed of its completion and the artist's enjoyment of the process.

A paintbrush consists of a handle, a ferrule, and the fibers. Production of brushes and particularly the selection and shaping of the fibers is a skilled task. A good oil-painting brush should have fibers that are hardwearing, secure, and tight fitting; a firmly attached, seamless, metal ferrule; and a long, strong, sealed handle.

1 Hog bristle is the most common and useful fiber for oil-painting brushes, particularly on textured surfaces such as canvas. The durable bristles have a lot of "spring," allowing them to hold their shape, and the thickness of the fibers increases the paint-holding potential.

A hog-bristle brush can apply a lot of paint quickly to a broad area and so is perfect for underpainting and all large-scale work. Most bristle fibers have a unique split end and the finest quality brushes exploit this with a firm body below a surprisingly soft tip.

2 Sables are more often used in watercolor painting, but they can also be of use in oil painting. The thin, fine-tipped hairs are good for fine detail, particularly on smooth surfaces, such as panel or metal.

Sable brushes tend to hold on to their paint load and are not ideal for moving oil paint around the canvas. They are the least hard wearing of all the fibers and can lose hairs from around the edge of the ferrule if they are overused. Kolinsky sable is renowned for its ability to retain a point; but there is a wide difference in quality across the range of sables.

3 Synthetic/sable blends offer a softer, more absorbent, version of the nylon brush but the fibers may deteriorate at different rates. (Squirrel, badger, and ox hair are also used, all possessing similar qualities to sable and synthetic fiber brushes.)

4 Synthetic fibers, such as nylon, offer a cheaper alternative to sable that (for the oil painter) can be equally useful. They tend to have the fine hair width of sable combined with the greater spring of hog bristle, and if properly maintained will last well.

THE OIL-PAINTING BRUSH

Fibers Ferrule Handle

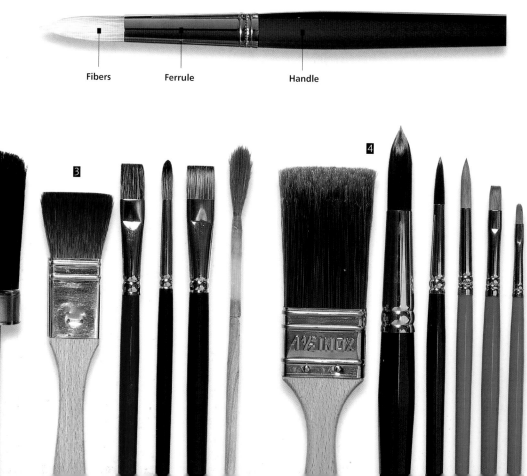

Care of brushes

Fully clean brushes after each painting session—first on a rag, then in mineral (white) spirit, and finally in warm water with soap. Then rinse the brushes, squeeze out the water, and lay them out flat rather than upright to prevent moisture from entering the ferrule and loosening the hairs. (You can maintain the shape of rounds by using a spiral of thread, as in the illustration.)

Do not leave brushes in jars of mineral spirit, as this will encourage the fibers to splay out and increase the release of fumes into the studio. Brushes should not dry within a painting session; if you wrap them in a plastic bag to limit oxidization, they can be stored overnight without lasting damage.

Shapes of brushes

It was the introduction of the metal ferrule, in the nineteenth century, that allowed brush makers to shape brushes more consistently. Today there are four principal shapes of brush for standard easel painting: round, flat, bright, and filbert. Depending on the technique, finish, or scale of a picture, some specialist brushes may also be useful. (For priming and varnishing brushes, see Studio equipment, page 110).

1 Rounds are the most traditional shape of brush and have been the principal oil-painting tool throughout history. The fibers are gathered in a circle, with the natural curve of the hairs pointing inward. A round brush holds the paint well and creates understated, rough-ended marks that are ideal for traditional illusionistic (blended) painting.

2 Flats hold the paint well, but the fibers can easily splay apart in the non-bristle versions if the brushes are not well kept. Flats are useful for creating an even, one-touch style in alla prima painting and for clean-edged marks.

3 Brights are shorter versions of the flat brush, and are often used by colorists, as they can create controlled, calligraphic, slab-like marks across the surface. As a bright does not hold much paint, it can be useful in controlling wet-on-dry scumbling, but the shortness of the fibers can make it difficult to clean.

4 A filbert is a good, general-purpose brush, shaped somewhere between a flat and a round, and sharing some qualities of both. The filbert has a dab-like subtle stroke and a linear quality when used on its edge. This flexibility makes it useful for depicting flowing subjects, such as cloth, trees, and the human form.

5 Designer brushes are short-handled, narrow rounds, usually sable or nylon, used for fine details in the later stages of a painting.

6 Riggers are narrow and long rounds of sable or nylon, and are invaluable for painting the thin lines found in branches, buildings, clothing, and so on. Liners are signwriting brushes for a similar use, but with a chiselled tip.

7 Blending or "fan" brushes are used dry, without being loaded with paint, to blend two or more areas of wet paint into a smooth transition or to remove the brushstrokes from an application of paint.

8 Decorators' brushes are used for painting on a large scale. Good-quality house-painting brushes are convenient and inexpensive. They are effectively flats with short handles; also available are "continental" decorators' brushes, which are large rounds with longer handles.

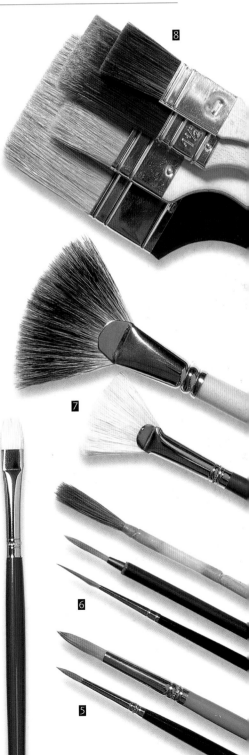

EQUIPMENT 2 Palettes

Using a palette allows you to have your paints and medium immediately to hand. This encourages speed and spontaneity, and frees you to concentrate on your painting.

A palette may be made of wood and held on the arm, or of a piece of thick plate glass and mounted on a table or movable trolley. Many painters work from a combination of both. It is good practice, particularly when using a small range of colors, first to mix as many colors and tints as possible on a glass sheet, using a palette knife, before transferring them to a portable palette. Plastic palettes are not recommended, because of the corrosive nature of the thinners used in oil painting.

Shape of palette

The traditional oil-painting palette is large and kidney shaped, with a thumb hole and an inlet for brushes to stick through. The shape allows you to hold the palette close to your body, resting on your arm. The thumb hole is placed to give better balance; large palettes often have weights on the inner edge for this reason.

Smaller palettes tend toward an ellipse shape, giving a larger mixing area, or sometimes a paddle shape. Rectangular palettes are primarily designed to fit specific painting boxes (in which they may be carried with wet paint still laid out), but they are also useful shapes for the studio. Disposable tear-off palettes are adequate, but they do diminish the pleasure to be had from finding one's own favorite palette, and the gradual accumulation of oil-coated papers in the trash can is a potential fire hazard.

Color of palette

The color of a palette is an important and yet often overlooked aid to efficient color mixing. Ideally, a palette should be the same hue and tone as the ground of the canvas on which you are painting. If you paint on a variety of grounds, a neutral, mid-toned gray is probably the best option, with a spare white palette for glazing work. This may involve having to cover a beautiful wooden surface with gray paint and then applying several coats of yacht varnish, sanding between coats to achieve a perfectly smooth neutral surface. Glass palettes can be transformed by slipping pieces of paper underneath that correspond to the color of the ground being used.

Palette care

Clean your palette after every painting session. This not only keeps the palette in good working order, but also allows you to reconsider the arrangement of colors and mixtures each day. If, for continuity, you need to keep color mixtures from one painting session to the next, transfer them to glass and cover them with plastic.

If a palette becomes encrusted in dried paint, it is best to remove the whole surface with a water-based paint stripper and prepare the surface anew, either by oiling down the wooden surface or by painting and then varnishing.

Other useful equipment

1 **Palette knives** are used for mixing, applying, and removing paint, and are available in a variety of shapes and sizes. They should have a well tempered blade that is thin but flexible and firmly attached to the handle. A good-quality palette knife outlasts most brushes and is a good investment.

The standard palette knife is long, flat, and flexible with a rounded end; there is sometimes a crank in the blade near the handle to give more clearance for the fingers. Large knives are used for applying oil grounds to canvas, while smaller ones are ideal for mixing paint on glass.

2 **Painting knives** are always cranked, with a narrow shaft leading to a leaf-, trowel-, or lozenge-shaped blade. They are primarily designed for applying paint in an impasto manner, but their shape makes them ideal for mixing gradated tints, in small quantities, on the palette or glass.

3 **Rags** should be constantly at hand, ready to mediate between brush, palette, and painting. Ideally, use a lint-free, absorbent material such as an old washed cotton shirt that will not release fibers into the paint film. A rag can be a vital drawing tool during the underpainting stage, wiping back paint to reveal the ground layer.

4 **A mahl stick** helps to keep a steady hand away from the picture surface when you are painting details or areas surrounded with wet paint. There is really no reason to buy a mahl stick; simply tie a cloth bundle to the end of a cane. Remember that the end of the mahl stick should rest on the edge of the picture, not on the stretched canvas surface. With practice, you should be able to manage a mahl stick, a palette, brushes, and a rag all in one hand (see Painting position, below left).

Dippers

Dippers or "pans" are attached to the side of the palette to provide easy access to mediums and solvents. They are available in metal or corrosion-proof plastic, and the screw-top versions are particularly suitable for painting outdoors. Dippers should be an appropriate size for the palette and brushes, with small openings to prevent evaporation of thinners, and they should be placed away from the main color-mixing area of the palette. To avoid confusion, place a premixed medium of oil and thinner in dipper 1 and use it solely to dilute paints; place a solvent, such as mineral (white) spirit, in dipper 2 and use it only occasionally to clear a brush of paint that cannot be removed by wiping it on a rag.

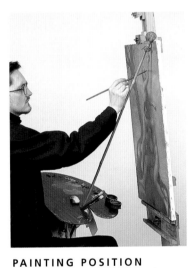

PAINTING POSITION
The painter above has leant the easel forward to minimize glare, and is resting the mahl stick on the edge of the picture to work on a detail. During general painting the brushes are best held closer to the end of the handle in order to keep a greater distance between painter and picture.

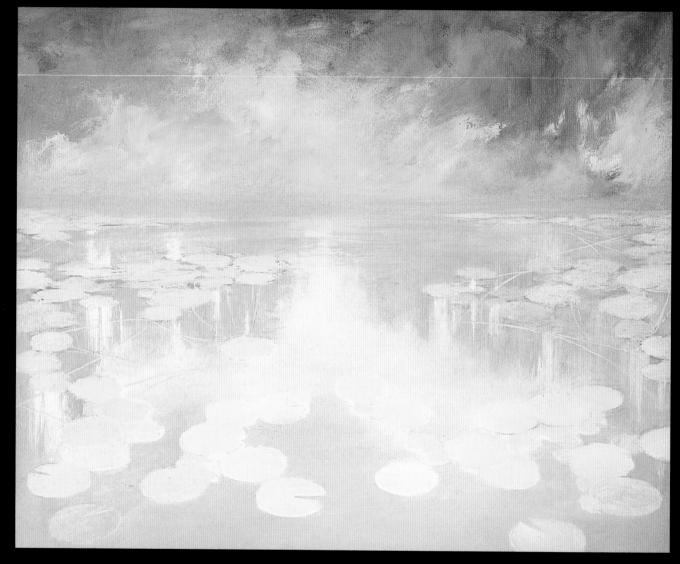

Giverny III
Paul Kenny
Oil on canvas, 1993
34 x 28 in. (86 x 71cm)

Approaches to form and color

This chapter outlines many of the traditional approaches to form and color, along with the related topics of expression and design. Form is explored first, as this was arguably the most important element of picture making before the modernist movements of the late nineteenth and early twentieth century. Traditionally, moreover, students of painting have often learned to handle paint and describe form monochromatically before exploring color. The depiction of form also relates directly to preparatory drawing and sketching.

Color breathes life into a painting and is more immediately able to move the senses and emotions. The sections dealing with color introduce the reader to the three elements—hue, value, and intensity—and explain how they are interrelated. There are also practical suggestions on how to mix paints and arrange them on the palette.

The aim of the sections on design is to provide you with some guidelines on how to plan your painting and arrange your subject within the picture space to best effect. By looking at how some of the great artists of the past have worked, you are encouraged to begin developing your own personal style.

Illusionistic form

If a form within a painting appears to possess actual volume and depth, defying the inherent flatness of the picture surface, it is called illusionistic form. We notice form both real and depicted by the way light creates different tones across a surface. In order to make flat canvas evoke the three dimensions of the real world, artists first had to light the subject and then note the changes that occurred across its surface. Leonardo Da Vinci, amongst others, established conventions that enabled artists not only to reproduce reality with economy and precision but also to invent light and shadow when painting purely from the imagination. We encounter these simple conventions whenever we attempt to paint a realist subject. Apples, faces, even clouds, all respond predictably to the effect of light upon them.

The effects of light on simple forms

Here are the recurring effects that take place when light falls on an object and the terms that are commonly used in relation to the treatment of subjects within a painting.

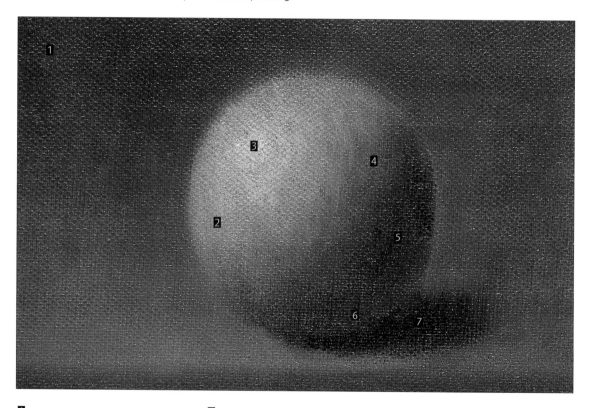

1 Light source The light that falls on an object can come from a single or several sources; it may be bright or dim, diffused or focused. It is often integral to the narrative within a picture. Both its position and its intensity have a profound effect on the appearance of the object.

2 Light mass is the area of an object that receives direct light. Depending on its angle to the light and the distance from the light source, the light mass may contain variations within it.

3 A highlight is the brightest point on an object. It is found in the middle of the light mass and is a reflection of the light source, conveying its diffusion and location. Highlights give clues to the surface texture of objects.

4 Half shadow or "turning" At a certain point on the surface of a curved object, the light mass "turns" into the shadow mass and an area of twilight appears. The width of the turning can vary along its length, marking subtle changes in the rate of curvature across a surface.

5 Shadow mass is any part of an object that faces away from the light source and is not directly illuminated.

6 Reflected light is dim light that is reflected into the shadow mass from nearby surfaces. Reflected light helps to complete the roundness of objects and can add to the sense of unity in a picture.

7 Cast shadow falls from an object onto surfaces around it. In a painting, a cast shadow makes an object more distinct from its surroundings and when cast below imbues them with a sense of weight.

Direction of light

Movements in art can be differentiated as much by the way light and form are manipulated as by their subject or style. Altering the position of the light source in relation to the subject creates different moods.

CLASSICAL (THREE-QUARTER) LIGHTING

This describes a diffused single light source from various locations above the subject, which gently illuminates producing descriptive half tones and subtle shadows. During the Renaissance, this kind of lighting would have been intended to appear as if heaven-sent.

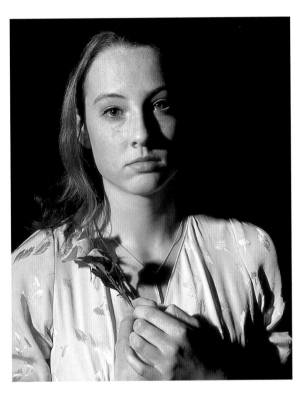

CHIAROSCURO

This term has come to describe a heightened light effect with strong light masses and a darker, more generalized shadow mass. The half tones may be acute and there is a reduction in the amount of reflected light. The style is very much associated with the work of Caravaggio and the early seventeenth-century Baroque period in Italy. He introduced a more earthbound and focused light source, illuminating scenes from the side or from within a scene in order to heighten the drama and the immediacy of the forms.

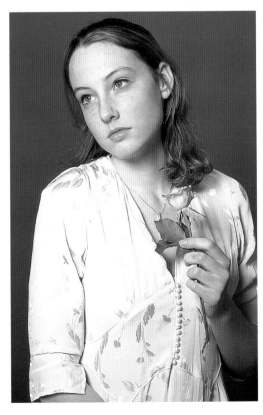

FRONT LIGHTING

When a figure or object is lit from the front, the form is flattened, presenting the viewer with a broad light mass surrounded by a half tone that recedes into an insignificant shadow mass. Ingres used front lighting to emphasize the lyrical outlines underpinning his compositions, and Manet found that lighting figures from the front gave them a stark realism in much the same way as the modern-day effect of flash photography.

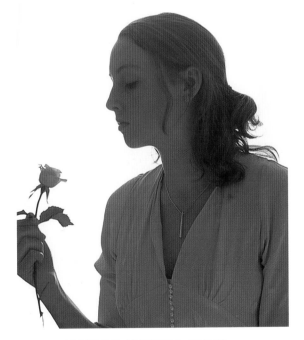

REAR LIGHTING (CONTRE-JOUR)

A subject may be lit from behind or painted against a lighter background, which flattens form and creates an outline of crisp light. This method of altering the tonal hierarchy in the picture is used to give more emphasis to the actual form and depth of the interior, as in many paintings by Vermeer, or to offer an alternative light scheme within large complex scenes, as in works by Delacroix or Géricault.

FORM AND COLOR 2

Form through line and color

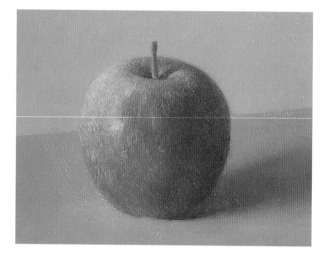

Painters have always exploited the characteristics of line and color alongside an illusionistic approach to form; but the development of photography in the late nineteenth century forced the painter to reconsider this balance. Oil paint was no longer the only medium that could truly mimic the appearance of the real world, and so there subsequently developed many more ways of approaching form. Line and color can both be used to differentiate forms from one another and to defy the limits of the picture plane effectively.

ILLUSIONISTIC FORM
This apple is painted in a traditionally illusionistic manner, with naturalistic form and color. Notice the absence of harsh outlines or overly expressive brushwork.

Delineated form

Beneath the planes and surfaces laid down in an oil painting there is the influence of drawing—a linear network denoting edges, movement, and connections between objects. It is possible to bring such aspects of drawing into the painting; and indeed, the flexibility and removability of oil paint lends itself to such processes.

Painters such as Degas, Cézanne, Van Gogh, and Picasso extended the drawing process into paint, exploring to a greater extent than before the edges and shapes of objects. Form is often flattened or simplified; sometimes it is exaggerated, deconstructed, or re-formed. Although objects may not possess a great tonal gradation they can, through a linear border, appear solid and distinct. The artist can encourage the linear appearance of subjects by lighting from the front. The subtler effects of modeling form, such as highlights and half tones, are often replaced by pattern and decorativeness.

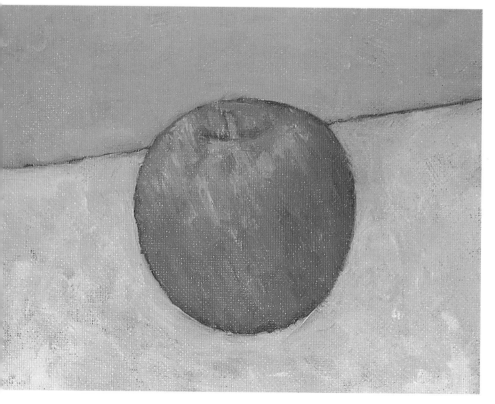

DELINEATED FORM
Here, the dominant statement describing form and shape is the outline, and the internal surfaces and shadows are subservient to it.

Impressionistic form

Painters such as Titian and Turner understood that the world contains not only three-dimensional objects but also atmosphere, space, and the sensation of color. When oil paint is used at its full range and physical potential, it is the ideal medium for capturing such sensations.

The Impressionists crystallized these ideas by heightening the optical appearance of objects through the inventive use of color and color mixing. The edges of forms became diffused into their surroundings in an attempt to grasp the visual essence of a moment rather than provide a timeless, objective description. By depicting less defined subject matter, such as water, flowers, or landscape, lit with intensity and ambience, the painter today can echo the freshness found in a Monet or Pissarro.

IMPRESSIONISTIC FORM
In impressionistic form, colors reflecting off different surfaces contrast and combine together to represent form.

Abstracted form

Abstraction is the liberation of form from subject—the expression of the drawn mark and the exploration of color sensations are pursued as subjects in themselves. "Form" in this instance refers to original creations—the marks, shapes, motifs, and textures of the artist. The development of abstract painting in the twentieth century has shown that formalist elements, such as line, gesture, design, color, and tone, can be expressive without needing to be descriptive.

Abstract art may seem difficult for many to accept, but by turning a still life or landscape painting upside down we soon see how forms can lose illusionistic qualities and appear "abstract."

ABSTRACTED FORM
The principal form in this picture has a character only distantly related in shape and surface to the original apple, yet it still functions as an important motif.

CLASSICAL LIGHTING
Leeks and saucepan and cabbage
Brian Gorst
Oil on canvas, 1993
24 x 16 in. (61 x 41cm)

The vegetables in this still life are lit from a high window beside the artist. This light illuminated both the subject and the canvas while the work was in progress. Classical lighting produces a certain tonal description without losing the qualities of outline and shape.

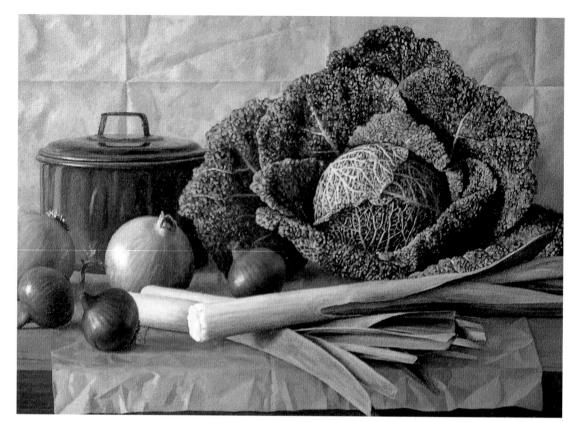

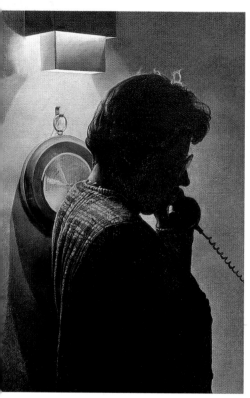

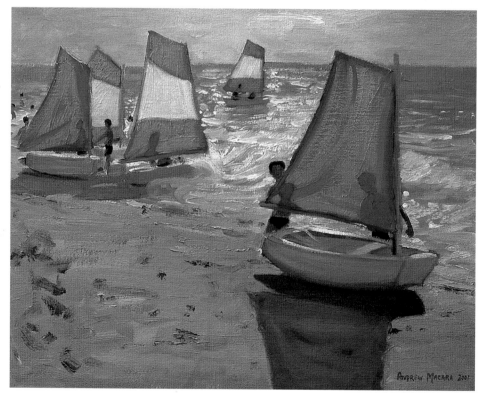

CONTRE-JOUR
The telephone call, **Paul Bartlett**
Oil on paper, 1993
17 x 24 in. (43 x 61cm)

A figure against the light has a strong sense of silhouette, creating a characterful profile view. Notice how the subtly observed edges around the head and shoulders make more plausible the simplicity of this design.

FORM THROUGH COLOR
Pink sails, France, **Andrew Macara**
Oil on canvas, 2001
18 x 14 in. (46 x 36cm)

Bright and broad areas of color are used here to capture the effects of afternoon sunlight. The sand appears baked and hot, the sail is glowing as the sun pours through it, and the water seems crystallized by the glancing light.

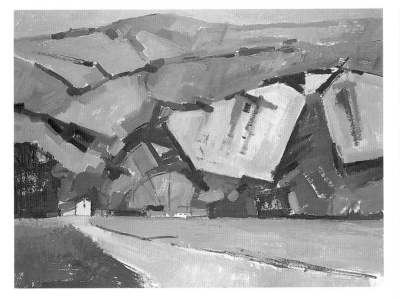

SEMI-ABSTRACTED FORM
Untitled
Barry Freeman
Oil on paper, 2003
23½ x 16½ in. (60 x 42cm)

The hard-edged shapes of this hillside are rationalized into flattened and almost abstracted forms. This has been achieved through the powerful mark-making of brush and palette knife.

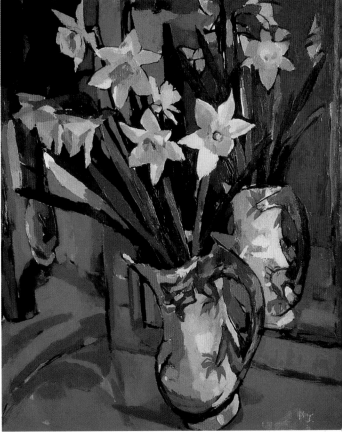

DELINEATED FORM
Daffodils and dragon jug
Tia Lambert
Oil on canvas, 1990
34 x 40 in. (86 x 102cm)

Although there are only a few painted outlines in this still-life study, the flatness of the color sections gives it a strength of design that is essentially linear. The artist illuminates the subject from the front with spotlights to accentuate and control this effect.

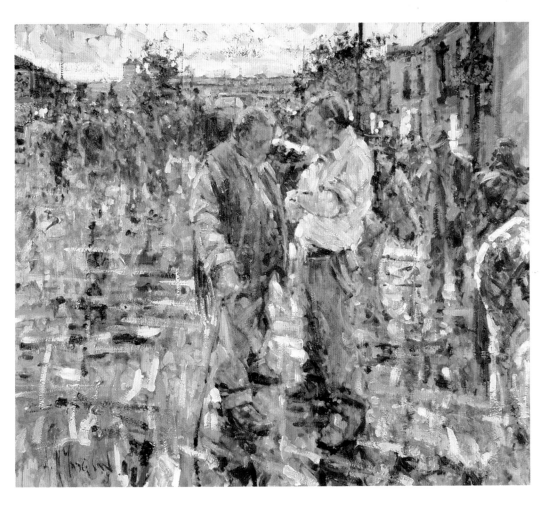

IMPRESSIONISTIC FORM
Figures at dusk (study for *Tallow horse fair*)
Arthur Maderson
Oil on panel, 2002
54 x 48 in. (21 x 19cm)

This busy street scene, with low light reflecting off the wet road, is an example of how color can be used, without any definable outline, to depict form and light.

FORM AND
COLOR 3

The elements of color

Color describes the nature of the light that we receive through our eyes. This visible light is a narrow section of the electromagnetic spectrum, and different light waves are emitted from different objects and paints. Every object that we see and try to depict has a color and the elements of color are always threefold: value, hue, and intensity. An understanding of these characteristics, and how they are inextricably linked, is a vital part of the painter's craft.

Value

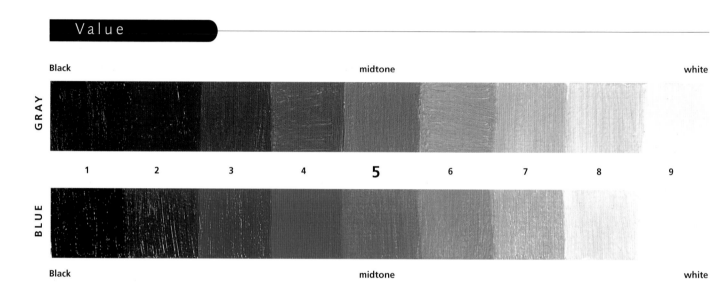

Black **midtone** **white**

GRAY

1 2 3 4 **5** 6 7 8 9

BLUE

Black **midtone** **white**

The value, or tone, of a color is essentially its darkness or lightness. It is scientifically related to the height of the light wave and describes its overall reflectance. Value ranges from black to white, with varying increments in-between. The artist Franz Kline often worked with just two divisions—white and black; but it is said that the French painter Ingres required his students to mix over 200 discernibly different tones from black to white. The American colorist Albert H. Munsell developed a useful color classification system with nine values in which black = 1, white = 9, and a midtone is placed at 5.

A tint is a high-value or lighter color (often achieved by mixing the basic color with white), while a shade is a low-value or darker color (often achieved by mixing the basic color with black). Tints and shades tend to possess less intensity than full-strength colors closer to the middle values. Different colors of a similar value have a fraternal relationship with one another that can be highly harmonious.

Black and white, at the extremes of the value scale, can be overdominant and disruptive in a picture. An area of black can isolate and disunite the colors around it and white can stifle the subtlety of color harmonies. When black or white is used as a solid color in a painting, it is often in order to stress the emotional or symbolic nature of other colors, as in Mondrian's geometric abstractions or the near-heraldic simplicity of a court portrait by Holbein.

Although oil paint has a much greater tonal range than watercolor, tempera, and most drawing media (and, unlike acrylic paint, it maintains a constant value during the drying process), the value range on the palette very often cannot match the range seen in real life. Moreover, the value range found in nature is often deliberately abbreviated and modified by artists for particular effects. The Impressionists, for example, limited the tonality of their paintings in order to emphasize color relationships; conversely, Caravaggio limited the variety of color to highlight dramatic tonal effects. In his portraits, Rembrandt often rationalized broad areas in the background or clothing into simplified darks while expanding the value range of the light mass on the face.

Hue

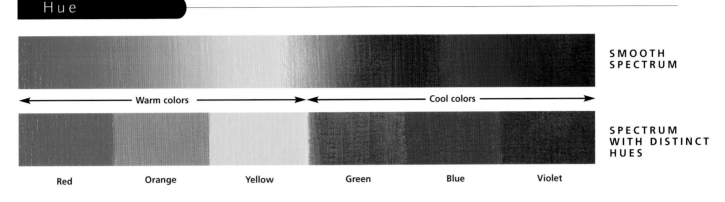

SMOOTH
SPECTRUM

←———— Warm colors ————→ ←———— Cool colors ————→

SPECTRUM
WITH DISTINCT
HUES

Red Orange Yellow Green Blue Violet

Hue relates scientifically to the length of the light wave, and ranges in a scale from red to violet, passing through orange, yellow, green, and blue. The scale extends farther than this into both ultraviolet and infrared, but these six colors form the spectrum that is visible to the human eye.

It is important to stress that all colors found in nature can ultimately be described as one of these six hues (R, O, Y, G, B, V) or increments between (RO, YO, YG, BG, BV, RV). Pink is of a red hue; navy is blue; brown and peach are both orange

hues; maroon becomes red-violet. All grays are biased toward one hue or another as, theoretically, are black or white.

It is vital that we understand the true hue of colors when mixing paints on the palette. This enables us better to neutralize or intensify a mixture with other hues.

A monochromatic picture is made up of only one hue, within which a vast variety of tones and strengths is available. A prismatic or full-color palette can achieve most hues in various tonal and chromatic combinations. Successful paintings are

often those that have a balanced and restrained use of hue, combining gentle contrasts with resonant harmonies.

The hue of a color can also be expressed in terms of temperature. Hues of red and orange tend to evoke warmth; blue and green tend to coldness; yellow and violet can possess either. Temperature is, however, highly relative, subjective, and often culturally specific. Warm colors can appear cool when surrounded by an even warmer color, and colors may aggregate to give an overall impression of coolness or warmth.

Intensity

FULL
STRENGTH
TO NEUTRAL
GRAY

Full strength green ————→ Neutral gray ←———— Full strength red

INTENSITY
OF YELLOW-
HUED
PIGMENTS

Lemon Yellow Cadmium Yellow Medium Naples Yellow Mars Yellow Raw Sienna Raw Umber (tint) Raw Umber

Intensity (sometimes referred to as saturation or chromacity) is the term used to describe the purity and strength of a color. This ranges from a full-strength bright color to a hypothetical neutral gray. A pure, intense color catches the eye in the same way that a crystal-clear musical note attracts the ear. Colors that are subdued or muted are commonly called earth colors.

The intensity range of pigments has greatly increased since the development of synthetic colors during the nineteenth century, and today so-called "day-glow"

colors push the intensity of certain colors even farther. Intensity affects the presence and relationship of colors: if the value and hue of two colors are equal, the one with the greater intensity will advance optically. Yellow Ocher may have the same hue and value as a Cadmium Yellow Deep, but it is more neutral and less intense.

Although colors tend to be less intense the closer they move toward black or white, different hues have their most saturated moments at different values. The most intense yellow, for example, has a

high tonal value, while the most intense violet is darker than the midtone. Artists learn to sense the intensity of a pigment and this becomes vital in the mixing of paints, especially with white.

It is important to monitor the degree of intensity across a picture, as the subtle neutralizing of colors is one way of creating depth. The underpainting of a composition is nearly always more muted and less intense than the subsequent layers, where notes of intense color emphasize and bring objects forward.

FORM AND
COLOR 4

The color wheel

Color wheels are principally diagrams of hue, constructed to illustrate theories of color, in which the linear shape of the visible spectrum is curved into a circle, joining red and violet together in the same way as twelve and one are joined together on a clock face.

Color wheels are used for different purposes, and although the order of the six hues is always the same, certain hues are given more importance in some systems than in others. Psychologists recognize that we mentally differentiate color into four primaries of yellow, green, red, and blue. Scientists studying light and optics subdivide their color wheel into red, green, and blue primaries. The Munsell industrial color classification system further extends this to five primaries of red, yellow, green, blue, and violet. The four-color printing system used in most commercial media has cyan (blue), magenta (red), and yellow as its primaries along with black; and it is to this final convention that most painters' concepts of color relate.

Painters classify red, yellow, and blue as primary colors, because they cannot be satisfactorily generated by other paint mixtures yet, hypothetically, can combine to create all other colors. Orange, green, and violet are described as secondary colors and are created by mixing their two neighboring primaries. Colors mixed from combinations of secondary and primary colors are known as tertiary colors.

Color relationships

PRIMARY, SECONDARY, AND TERTIARY COLORS

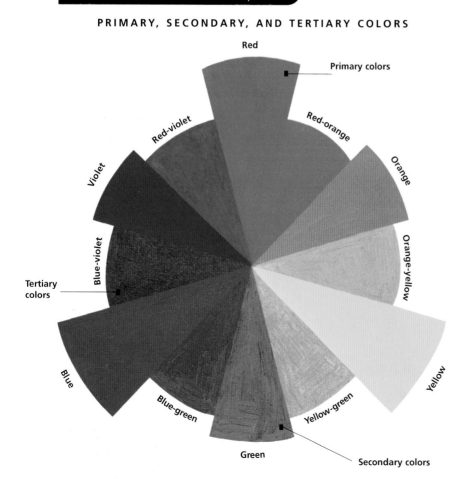

A color wheel shows how colors relate to each other, and so can help artists predict whether colors will harmonize or contrast in a painting. There are a number of different types of color relationships, each one creating a different mood.

Complementary colors are located opposite one another on the wheel; they tend to resonate when placed together. Red will appear vivid when placed next to green; yellow with purple; blue with orange. The intensity of the effect depends on the value and saturation of the colors in question: red and green may have a very resonant complementary effect, whereas the sheer luminosity of yellow can dominate a strong violet.

The pairing of full-strength complementary colors is seen as coarse and oversimple in most artistic settings and is more often found in design contexts. Complementaries are useful when painting with a limited palette, as they enable the artist to exploit relationships between colors to maximum effect. It is common in still lifes and portraits to paint backgrounds a subdued complementary of the main subject, the contrast pushing the subject forward to greet the viewer.

Simultaneous contrast refers to the use of a complementary color (instead of a neutral gray) in shadow areas to provide a visual link with the main subject and bring the shadow to life. An intense subject, such as golden sun-drenched snow, for example, will make the shadow mass appear blue-violet; the shadows of a human face can often appear slightly blue-green. (This effect may influence the color chosen for the painting surface.)

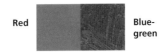

Red / Blue-green

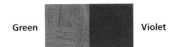

Green / Violet

Split complementaries are those adjacent to the true complementaries; they tend to offer more pleasing, harmonious pairings.

Triadic colors are found a third of the way around the color wheel from any given hue. Triadic pairings offer less emotive contrasts than complementaries, and three triads can form the basis of a balanced limited palette.

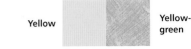

Yellow / Yellow-green

Analogous or diadic relationships occur between colors that are near neighbors on the color wheel and have the influence of a primary in common. Analogous colors are often used in design, as they offer decorative variety with limited color contrast. Analogous relationships are useful in bringing variety into single-color objects, such as cloth or foliage.

Adaptations of the color wheel

The painter's color wheel usually indicates all hues at their most saturated and consequently contains a range of values from the brightest yellow to the deepest violet. A color wheel may, however, show all hues at full intensity at a single value range or alternatively all hues at varying degrees of intensity. An adapted color wheel demonstrates how color limitations can be extremely interesting and pleasing. When artists produce their own color wheels they learn the vital skill of mixing paints into exacting values, hues, and intensities.

FULL-STRENGTH COLORS AT SAME VALUE

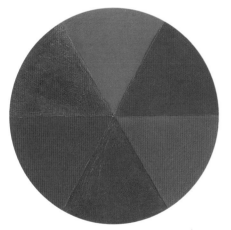

While red and blue are quite intense at this value, yellow is less so and appears muted in comparison.

TINTS WITH WHITE ADDED

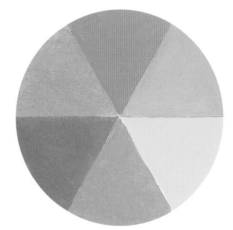

Even tinted with a little white, yellow remains strong against the high value cooler tints. Notice the way all six colors sit comfortably together in this instance.

VARIABLE INTENSITIES AND VALUES

This color wheel combines hue with three degrees of intensity. The prismatic colors of the outer band, when mixed with their opposite pairing to form the inner bands, begin to assume the appearance of earth colors.

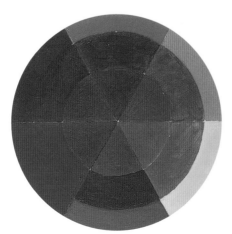

LIMITED (MUTED) COLORS AT DIFFERENT VALUES

Earth colors tend to be nearer in value and intensity to one another, and so these hues sit well together across the whole wheel.

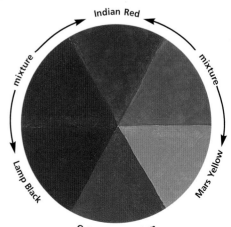

Indian Red

mixture

mixture

Lamp Black

Mars Yellow

Oxide of Chromium

Color mixing

When light falls on a painted surface, each pigment absorbs and reflects different hues in the spectrum. Full-strength colors reflect their own hue with various quantities of their neighbors', and absorb the light of the color that lies opposite on the color wheel. Black absorbs almost all light, while white reflects the complete spectrum.

When two pigments are physically mixed, their light-absorbing tendencies are combined in a process called subtractive color mixing, with more and more hues of light being subtracted or absorbed with each color that is added. All mixtures are therefore duller and less intense than their constituent pigments. The more pigments that are combined to create a color, the more neutral that mixture will be.

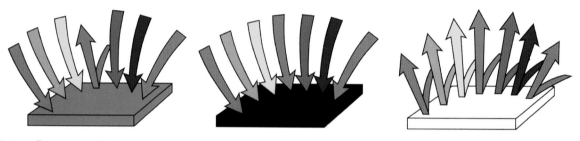

Green reflects green and absorbs other colors Black absorbs all colors White reflects all colors

The effects of mixing colors

The three primaries when mixed in pairs (red, yellow, and blue) produce the strong secondaries that lie between each pairing on the color wheel. When all three primaries are combined, the result should be close to a dark, neutral gray. The hue, value, and intensity of each mixture will depend on the strength of the primaries, and the principles remain the same for muted primary hues of any value.

When full-strength secondary colors, such as Cadmium Orange, Viridian, and Dioxazine Violet, are paired together, they can also produce muted, though pleasing, tertiary versions of the primaries. All other tertiary colors are mixed from combinations of the six primary and secondary hues.

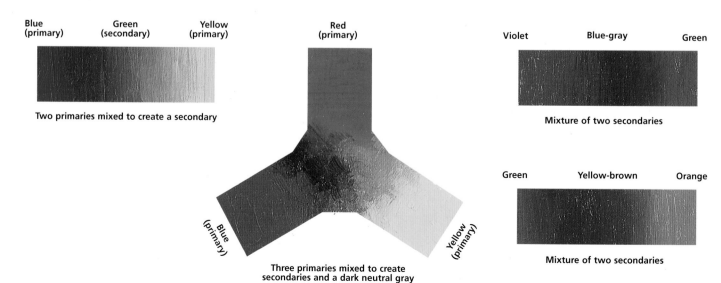

Blue Green Yellow Red Violet Blue-gray Green
(primary) (secondary) (primary) (primary)

Two primaries mixed to create a secondary Mixture of two secondaries

Blue Green Yellow-brown Orange
(primary)

Yellow
(primary)

Three primaries mixed to create Mixture of two secondaries
secondaries and a dark neutral gray

Colors that are opposite each other on the color wheel (complementaries) neutralize each other when mixed together, moving each color closer to gray. This effect forms the basis of an economical and efficient color-mixing practice. Complementaries can be used instead of grays to lessen the intensity of a color; if a dark complementary is used to lower the value of a color, it has less impact on the intensity than mixing that color with black.

Theory, however, always has to be tempered with trial and error, as pigments all have different strengths and values and can behave differently. It is difficult, for example, to mix a true violet from even the purest red and blue; and although orange should, in theory, neutralize blue it often tends toward a green.

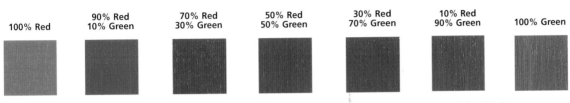

| 100% Red | 90% Red 10% Green | 70% Red 30% Green | 50% Red 50% Green | 30% Red 70% Green | 10% Red 90% Green | 100% Green |

Two colors mixed together at different percentages (value maintained in mixtures using a little white)

Approaches to mixing color

Color mixing occurs at different stages of the painting process: on the palette or glass before and during painting; on the picture surface either physically or through glazes; and often optically between the picture and the eye (see Pointillism, page 70). Colors can also be completely or partially blended and glazes can be thickly or thinly layered.

These methods have been used throughout the history of painting in intuitive and creative combinations. Rubens was renowned for his rich, transparent shadows and fleshy, opaque light masses heightened by partially blended highlights and cool turnings, mixed directly on the canvas. The French Neoclassicists favored a highly regimented palette, with dozens of earth-colored tints carefully premixed and applied opaquely with precision. It is important to remember that as long as the color effect in the pictures works well, it really matters little how it was arrived at, and so by trial and error painters should aim to develop their own solutions.

Using a palette knife rather than a brush to mix improves palette tidiness, saves time, and keeps thinners clean.

TIPS FOR BETTER COLOR MIXING

- Make each mixture using as few colors as possible.

- Use a palette knife to mix paints wherever possible. This keeps brushes and thinners clearer for longer.

- Complementaries and triadic hues neutralize other colors and darken in more subtle and interesting ways than merely adding black.

- Use separate brushes for the light and shadow masses to avoid muddying color mixtures.

- Make swatches of pigments and mixtures, noting their toptone, undertone, and tint with white, along with their name and manufacturer.

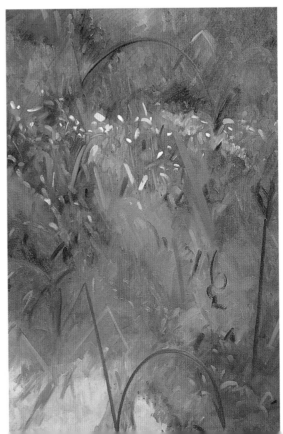

Garden contrasts
Roy Sparkes
Oil on canvas, 1990
30 x 36 in.
(76 x 91cm)

Here the main mass of the green is built up of multiple colors, mixed wet-into-wet on the canvas and concluded with single-stroke impasto marks that are left unblended.

Color palettes

An artist's choice of colors for each painting is called a palette. A limited palette is less intense, less contrasting, and made up of fewer colors than the subject. Alternatively, a palette can be extended into bright "prismatic" pigments for heightened and more intense effects. A palette may be chosen to cover all aspects at once within a picture, or it may be selected in order to paint one object at a time.

In choosing a palette of colors, you should consider the subject matter, the color of the surface on which you are painting, and the amount of time available for each session (which will determine whether complex color combinations can be tackled). The high cost of some of the saturated colors may also be a factor in your choice. Through trial and error, working with different subjects, you will learn which colors need to be replaced often and which are left unused, and adapt your palettes accordingly.

Tonal palettes

The appearance of real volume and depth within a painting is created through the use of different tones across a surface, mimicking the effect of light (see Illusionistic form, page 28). In this case, it is useful to mix and arrange tones on a palette in value scales rather than in color relationships.

1 Achromatic A palette of grays arranged in order of tone, producing grisaille paintings of varying values from black to white. It is sometimes used as a training palette to enable artists to develop their mixing skills and tonal awareness without the need to consider color.

2 Monochromatic A tonal palette of one hue. A monochromatic palette may be composed of either one pigment extended with black and white, a transparent pigment used on a light ground, or two or more colors of similar hue but different values. Underpainting (see page 53) is commonly done in a monochromatic palette, usually in an earth color, such as Raw or Burnt Umber, Terre Verte, or Raw Sienna.

3 Single-object palette Often a palette is laid out in order to paint a single object in its local color (the color of the actual surface of the object, disregarding any reflected or ambient color). Single-object palettes were often used in fresco painting and are sometimes necessary in a larger picture. Such a palette may be close to a monochrome arrangement in tints and tones of one color.

4 Flesh palette Flesh is traditionally painted in a different session to other aspects of a picture and the palette may be arranged with three corresponding tonal "strings" of yellow, red, and a neutral gray. This allows the painter to paint in a tonal manner while altering hue and intensity, responding to the enigmatic color changes found on the human form.

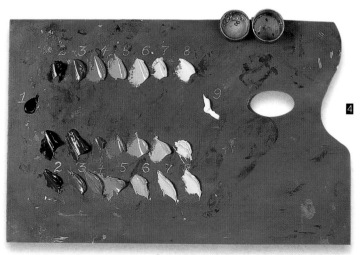

Earth palettes

An earth palette is the traditional palette of the pre-modernist age, when colors tended to be taken from the earth rather than synthesized artificially.

5 **Limited earth palette** It is said that Apelles, the greatest painter of antiquity, used a palette of yellow, red, white, and black to create pictures of astonishing realism. This can be replicated with Yellow Ocher, Red Oxide, Lamp Black, and white, producing muted primaries and concordant secondaries. Many painters, such as Velázquez and Rembrandt, used very few pigments and yet, by carefully offsetting warm and cool passages of paint, achieved a balanced color scheme. The simplicity and natural harmonies of this kind of palette make good results easier to achieve and mean that it is extremely useful to the untrained painter.

6 **Full earth palette** In many cases the limited earth palette needs to be extended to achieve a wider variety of hue and intensity. Landscape painters may add greens and use more dark earth browns; a portraitist may need a purer red, violet, or blue. It is important to include colors that do not make the intensity of the overall palette too bright.

5

6

Prismatic palettes

Throughout history, artists have continued to add brighter colors to their palettes as they became available, and this is reflected in the full-strength colors of prismatic palettes.

7 **Triadic** The simplest prismatic palette is probably one with full-strength red, yellow, and blue, from which a wide range of hues can be produced. The Fauves and early Abstractionists like Kandinsky and Mondrian preferred the striking simplicity of this palette. Cadmium Reds and Yellows combined with Manganese Blue produce rich secondaries, and French Ultramarine, Alizarin Crimson, and Viridian are commonly used to add depth of tone and transparency. As with the four-color printing process, this choice of primaries may be most effective on a pale ground.

8 **Full palette** This is a palette using an unrestricted range of pigments, often with a warm and cool version of all the primaries and secondaries, deep transparent colors, and possibly more than one white. A full palette was used by colorists such as Seurat and Renoir and many twentieth-century painters. Most full-palette arrangements use paint straight from the tube rather than premixing tints with a palette knife, and painters using this kind of palette may avoid the use of black.

9 **Glazing** This is a palette composed of transparent pigments of full-strength colors (sometimes the brighter earth colors). The value of the palette surface itself has to be high, if not white, to see clearly the strength of glazes.

7

Arranging color palettes

All artists lay out their palettes according to their own tastes, but here are a few suggestions of ways to arrange the colors.

Continuous spectrum The most common way of arranging colors is in a continuous line of hues according to the color spectrum. This makes more sense in palettes without browns, grays, or black, such as are used in impressionist or broken-color techniques.

10 **Warm/cool** Another way of arranging full-color or extended earth palettes is to lay out all the blues, greens, and violets in one line of colors and the reds, oranges, yellows, and browns in another. The white acts as an axis between the two strings. This

encourages a color scheme that is balanced in temperature, with the complementaries easily identifiable on the palette.

11 **Transparent/opaque** Setting out all the transparent colors in one line and the opaque colors in another is a useful arrangement for painters exploring a combined transparent and opaque method of paint application.

8

11

10

9

FORM AND
COLOR 7
Expression

Painters all respond to a subject in a different way, displaying in their work physical and emotional characteristics as unique as their fingerprints. Oil paint encourages such a wide variety of application that it can either accentuate the personality of the painter or refine and conceal authorship. Indeed, the twentieth century has brought us highly gestural "action" paintings alongside mechanistic superrealist works.

An expressive painting might be described as one in which processes of design and manufacture are explicit in the final artwork. This can manifest itself through a painter's brushwork and approach to form and color, and may be the result of careful deliberation or subconscious intuition.

Brushwork

Brushwork is the handwriting of the painter and is perhaps the most physical of all modes of expression. Different sizes and shapes of brush can obviously have a major influence on brushwork, as can the length of the brush handles, the texture of the paint or surface, and whether the painter is standing or seated. Size and timescale will have a profound effect on the finish of an artwork.

Many painters, such as Frans Hals, Delacroix, and John Singer Sargent, are celebrated for their loose, "bravura" brushwork; and the Abstract Expressionists were defined by their free style and use of bold gesture. Artists find it can be liberating to use a larger brush than normal and to paint with arm outstretched in a relaxed manner.

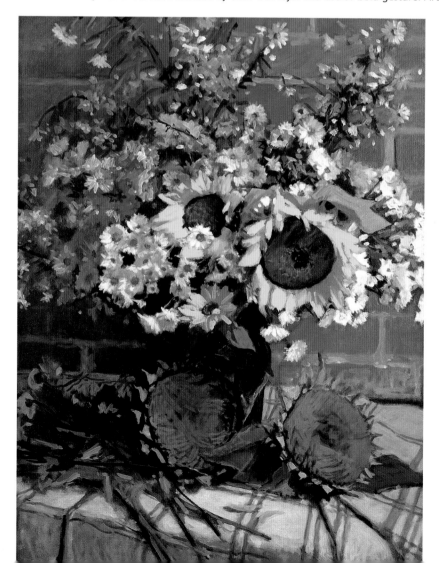

Other artists blend and tease wet brushstrokes together, until smooth or unbroken areas of form or color are created. The effect is often to evoke the surface of objects in favor of emphasizing the flat surface of the picture, as is often the case with more broken brushwork. Jan van Eyck, Ingres, and George Stubbs all rendered their pictures to a highly finished state, using smooth surfaces and soft brushes.

Remember that the degree of naturalism within a picture does not depend on refined brushwork. Many painters, from Velázquez to Lucian Freud, have achieved an arresting realism through the well chosen deployment of quite loose brushstrokes and scumbles.

Sunflowers and Michaelmas daisies
Kim Williams
Oil on canvas, 1993
26 x 32 in. (66 x 82cm)

Loose brushwork—one stroke per petal—is here used to good effect to evoke an organic and transient subject matter. The brick wall is more soberly treated, which helps push it back visually.

Form sense

Form sense is as much to do with the eye as the hand, and describes the painter's approach to the edges of form. Shapes or forms within a picture can be described as open or closed depending on how much their outside edge or outline dominates the color and shape of their mass. Form sense is equally present in the motifs and features found in abstract picture making.

A closed-form painting will often have a carefully delineated underdrawing filled in with color, the forms being separated from one another by clear edges. Artists such as Holbein, Poussin, and the English painter Stanley Spencer all display closed-form tendencies, and their work leans heavily on a pre-drawn outline.

Open forms have less distinct edges, are more prone to revision mid-process, and may well invite greater interpretation by the viewer. In the absence of closed-form edges, the eye arguably moves more freely across the light, color, and values of the picture. The tonal solidity in the compositions of Rembrandt shows how the open-form painter is instinctively drawn toward masses of light and shade before considering the enclosing edge.

Portrait of Kim Williams
Brian Gorst
Oil on panel, 1995
10 x 16 in. (25 x 41cm)

Throughout this closed-form portrait, the shapes are contained within clearly defined borders and there is no attempt to break up edges with looser brushwork or impressionistic color.

Exaggeration

Both form and color can be exaggerated (or simplified) for expressive and emotional effect. Exaggeration of form is sometimes used to ease a figure into a more harmonious composition, as in the work of Raphael. It is, however, to depict human emotion with greater impact that exaggeration is most often employed. It can also be interesting to bring to oil painting some of the freedom and carefree attitude of modern cartoons and caricatures.

Exaggeration of color has been so ubiquitous in art since the development of brighter prismatic colors that impressionistic or expressionistic styles of painting have become commonplace. Heightened color can have a sensory impact in itself but, more importantly, by altering the natural color of subjects the painter can induce an unusual or unexpected emotional response.

Exaggeration is more acceptable if the picture maintains an internal logic and consistency. The figures of Egon Schiele, for example, are renowned for their tortured elongation, yet maintain a feasible bone structure; and the odd, surreal, forms created by Salvador Dali emerge out of an equally strange, yet fitting, landscape.

Traditionally artists have had to earn the right to full expression in the ways described above. Great masters such as Titian, Velázquez, Goya, and Degas (whether through increased self-belief or failing eyesight) all gradually eased into a manner that was looser, more open in form, and less exacting.

Typewriter
Michael Taylor
Oil on canvas, 1995
28 x 26 in. (71 x 66cm)

Although the colors are naturalistic and the paint handling descriptive and concise, this picture achieves an expressive and dreamlike character through subtle distortions of the subject.

FORM AND
COLOR 8

Elements of design

There are many elements that go into the making of a picture. Just as a chef uses dominant and secondary flavors in a dish, so the painter plays different aspects off against one another: harmonies and contrasts of color; dynamic rhythms held within a static border; broad masses against frenetic detail.

SYMMETRY
Pomegranate
Jason Line
Oil on canvas, 2000
12 x 10 in. (30 x 25cm)

This symmetrical composition is quite daring, as the subject quickly demands the undivided attention of the viewer. It succeeds because of the pomegranate's plausibility of form and the asymmetry of the cast shadow.

Composition in design

It is useful to understand the different aspects of composition, all of which play a part in creating the painting's overall effect, even if in the end choices are made intuitively.

Format The overall shape of a canvas or other support is crucial. Regardless of whether a painting is landscape, portrait, or square in format, the ratio of width to height is more important in design terms than the actual size of the painting. Very wide or tall formats can place great stress on a composition to conform. A square is a notoriously difficult format to work within, having itself an appearance of completed perfection. Circles, ellipses, octagons; rectangles with an arch shape over the top; and multiple compositions such as the diptych (two pictures) and triptych (three pictures) can all be refreshing alternatives to the rectangular norm.

Picture edge The proximity of forms or shapes to the picture's edge can affect the perceived illusionistic depth of some subjects. Often the edge is intended to evoke a window onto a world; any objects that touch the edge without passing beyond it appear to sit on the surface of the painting. This can be used to good effect in trompe l'oeil or abstract paintings.

Symmetry The vast majority of pictures in the Western tradition are composed asymmetrically. It seems that a symmetrical composition conforms too resonantly and perfectly with the outside borders to be truly dynamic. A symmetrical composition is occasionally employed to evoke an iconic or spiritual simplicity.

Geometry Sometimes an artist attempts to construct a composition so that it conforms to a very formal series of shapes, lines, and proportions. Using geometry to hunt out special locations or ratios within a format is usually only successful for those who already have an acute intuitive eye for balance and harmony.

Rhythm in design

When we look at a picture we rarely take in all of it at once; instead, the eye is guided from one area to another. The painter has the potential to control how this occurs.

VERTICALITY
Through the trees
Brian Gorst
Oil on canvas, 2001
16 x 12 in. (41 x 20cm)

This is an attempt to capture the hypnotic nature of trees in a pine forest. Care was taken to vary the intervals between the trees and to retain their fractional tilts so as to avoid oversimplification.

Edges as lines Like the lines in a drawing, the edges of shapes lead the viewer's eye around the canvas from one point to another. Shapes may be manipulated for this very purpose.

Horizontals and verticals Horizontals and verticals are the simplest way of creating counter-movement in a painting. For instance, a landscape may have a dominant vertical (placed asymmetrically) subdividing the dominant horizontal thrust of the format. Horizontals and verticals always echo the line of the border, and so to limit this (sometimes undesirable) relationship they are often tilted or inclined slightly and are rarely placed too close to a parallel outside edge.

Focal points The eye of the viewer rests on areas in a painting that have, for a variety of reasons, more significance than others. In figurative painting this may be a

hand, a face, or other feature signifying a meaning or narrative; it may also be a noticeable shape such as a dot, a hole, or a sharp point. In abstract work, small areas of high- or low-value contrast or intense color may well hold more attention than a broader area of the same.

Diagonals Strong diagonals can add strength and vigor to a picture and often counteract the static nature of the common rectangular format. Whether they are steep or gradual, diagonals can propel the eye onward and so should be used with caution near the bottom right-hand corner of a picture as this is where pictorial interest often terminates.

Curves The curve is intimately related to the gesture of the drawing arm and is the movement most commonly found in traditional figurative subjects. Curving arcs can be broad, sweeping, meandering, or abrupt; and of all shapes, they contrast most strongly with the straight edge of the picture. They often evoke allusions to natural forms as in serpentine, arabesque, or spiraling curves.

CURVES AND DIAGONALS
Sowthistle and grass, **Brian Bennett**
Oil on canvas, 2001
30 x 18 in. (76 x 46cm)

The eye is taken on a figure-of-eight movement, with sweeping diagonals evolving into gentle curves at the base and at the uppermost reaches of the grasses.

Color in design

Whether painting a recognizable composition or a non-representational one, the deployment of color will always affect the success of the design.

COLOR ECHOES
The boatyard, **Alan Oliver**
Oil on canvas, 1999,
15 x 11 in. (38 x 28cm)

In this expressive picture, the eye is taken from side to side and from top to bottom via certain color echoes. The yellow of the sand can be seen faintly in the clouds, while the red buildings and green hull are echoed near the rudder and under the buildings respectively.

Value The way tones are distributed across a picture can have a subtle, even subliminal, effect on its balance and harmony. High-value areas compete with low-value areas for dominance, with quantity and location being vital factors. Large, medium-value areas in one half of a picture counterbalance smaller high- or low-value moments in the other.

Picture hue Most paintings have a general hue, which may derive from a single, dominant color or a combination of many constituent hues. It is useful to establish the hue of an incomplete painting as it may prompt a choice of colors that will add an element of opposition. (Picasso's famous Blue and Rose Period paintings were punctuated with subtle moments of warmth and coolness respectively.)

Color quantity This can relate to either the size or intensity of the general color masses. Areas of color can dominate a painting, depending on the quantity in which they are used, and their distribution should be carefully planned. Note that different hues have different effects: a small amount of yellow, for example, will dominate a painting more than the same amount of violet (its complementary).

Advancement Generally, cool colors recede and warm colors advance and this can affect the spatial design of a painting. This is frequently used to push distant cool hills behind warmer foregrounds in landscapes. Flat and opaque colors often appear closer to the picture plane than a transparent color of similar hue and value.

Color echoes When a single color is distributed at points across a painting, the eye can be pulled from one point to another. Color notes of this kind can tie disparate parts of a composition together as, in a similar way, rhyme can unify a poem.

FORM AND
COLOR 9

Design in practice

Oil paint has excellent sketching capabilities and some painters design their entire picture in paint on the canvas. Many artists, however, find it liberating to design a picture before they start painting, while they are free from the constrictions of technique and process.

The key to good design in painting is to be in control of the elements, and the most common way to achieve this is by simplifying and rationalizing the process. One can reduce the size of the task by sketching on a small scale; lessen the complexities of hue, value, and intensity by addressing each in turn; and maintain fluidity by working quickly, avoiding details.

Strategies to progress an idea

Studies are rehearsals for difficult aspects of a picture. They are usually drawings or paintings from life that contain information about the tones and colors to be used during the painting process. Difficult subjects, such as faces, trees, drapery, and so on, are all studied in general and specific terms to create a more fluent artistic vocabulary.

Sketches are often incomplete and unprepared, but they are invaluable in moving ideas forward. Whether you draw or paint your sketches, the process can help you to ease into a difficult or unfamiliar subject. Small painted sketches were common in France in the early nineteenth century as preparations for larger classical compositions, and the free and broken brushwork and lack of detail came to influence painters such as Delacroix and the Impressionists.

Copying and using reference material
Few artists have refrained from using the works of their predecessors as a stylistic springboard or as a source of reference material. Indeed, copying another painting is one of the most efficient ways of developing one's technique and taste. In the cartoon *The four seasons* (right) the sleeping figure of Winter was copied and reversed from Michelangelo's *Noah* on the Sistine Chapel ceiling.

Cartoons When painting large pictures and murals, it can be helpful to make an actual-size linear drawing of the preliminary study on thin paper and then transfer it to the painting surface. Cartoons were used primarily for frescoes and tapestries during the Renaissance, but they can also be used to rediscover an outline lost during the painting process.

Perspective plates In illusionistic pictures, particularly interiors and cityscapes, you can resolve complex spatial issues by making a carefully constructed plan of all the linear perspective information—horizon lines, vanishing points, traces, and so on.

Underdrawing materials

1 **White chalk** is used in place of charcoal when using a dark ground. It is also useful for drawing alterations on paint layers that have dried.

2 **Acrylic, watercolor, or thinned oil paint** are occasionally used on suitable grounds to draw an outline or a tonal drawing to be overpainted with oils.

3 **Charcoal** is the preferred medium with which to execute an underdrawing. It can be removed easily, provides a clear line, and is

useful up to a large scale. Charcoal lines rarely leave any indentation and, when covered, merge comfortably into the paint film.

Graphite pencil is not recommended as an underdrawing medium, as it can be only partially removed by the process of oil painting and the thin lines can re-emerge through aging paint films. Firm pencils can also leave unwanted indentations on boards or panels.

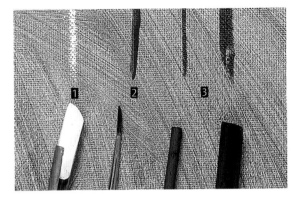

Methods for transferring preparative drawings

Tracing This is the simplest method of transfer: the initial sketch is made on thin paper, the back of which is covered in charcoal or chalk, and this is firmly secured to the primed painting surface. You then simply trace over the original lines of the sketch, using a ballpoint pen or pencil, to transfer them to the painting surface. When tracing onto board, take care not to press too hard as any indented lines will limit future adjustment.

Projection In this method, you simply project the sketch on to canvas using a slide projector or an enlarger, and then draw over the projected lines using charcoal or chalk. The method gives you complete editorial control and allows you to introduce photographic material into the design process. Both the projector and the canvas must be completely stationary to achieve the best results, and the light source must be perpendicular to the center point of the picture in order to avoid distortion.

Grids Using a grid is often the fastest method of transferring a sketch onto any scale. The way to do this is to place grids of equal squares on both the sketch and the canvas and replicate each square at a time. (Areas of detail may require more squares.) The line quality in the second drawing can be as sensitive as that in the original and there is scope for alteration during transfer.

Pouncing This is a traditional technique whereby the drawing is pin-pricked along its lines and laid over the painting surface. Charcoal dust is then rubbed through the holes to provide a faint, dotted outline. The lightness of the line is useful when working on pale-colored grounds and can be completely removed if the composition proves unsuitable. The original drawing is, however, damaged in the process.

Copy after portrait by Fantin-Latour
Brian Gorst
Oil on canvas, 1998
30 x 22 in. (76 x 56cm)

Techniques of painting

This chapter aims to show how methods of applying paint evolve naturally out of the painting process and how certain techniques can be useful for particular subjects. As well as providing you with the necessary technical know-how, the step-by-step demonstrations should also give an insight into some of the aesthetic decisions that professional artists are faced with during a painting session.

The techniques explored here rarely occur in isolation: artists instinctively combine a whole range of techniques in the same work. The paintings of J. M. W. Turner, for example, often combine thick impasto work with rich glazing, and the broken color found in the work of the Impressionists was frequently the result of an alla prima approach to picture making. With practice, basic techniques will become instinctive, enabling you to produce work that is free and confident.

While you are training and developing as a painter, you should make a point of trying out as many different styles and methods of painting as possible. Then just as musicians are drawn to particular instruments, you may find yourself committing to a certain method of painting.

TECHNIQUES 1 # Methods of application

Nowadays, there are so many ways of applying paint to a support that we can often be spoilt for choice. We have complete freedom of expression and access to a staggering array of paintings in many different styles. This is in marked contrast to the way oil painters developed their technique before the twentieth century. Then, artists were traditionally trained as apprentices, learning the skills and methods of their masters and peers, with limited exposure to alternative approaches. Van Dyck, Ingres, and even the great Leonardo Da Vinci all began by painting small passages of their masters' pictures (Rubens, David, and Verrochio respectively). In due course, each developed a unique and personal style of his own.

It is helpful to observe how pictures in galleries were painted. What color was the ground? How many layers of paint were applied? What kind of color palette was employed? (The works of followers and lesser masters are often easier to understand technically as their methods are, by implication, less subtle.) It can also be worthwhile emulating another artist for one or two pictures, and even executing copies of paintings. This, too, was common practice in the past: large paintings by Titian, for example, were copied by Rubens, who in turn was closely emulated by the young Delacroix.

The many different and subtle ways of applying paint can be simplified into three methods: transparent, opaque, and combined.

The transparent method

Suilven and shadow
James Morrison
Oil on board, 2002
60 x 40 in. (152 x 102cm)

This painting was created without the use of white paint, using the transparency or semitransparency of the colors (painted onto a fairly nonabsorbent white panel) to achieve highly atmospheric results.

The transparent method dates back to the fifteenth century, when the Flemish pioneers of oil painting used oil-rich transparent glazes over a pale ground or tempera underpainting. Light falls through the glazed color, reflecting back off the ground in a similar way to sunlight through stained glass. The transparent method has similarities to watercolor, as layers are built up gradually and any alteration in the design remains visible and is to be avoided.

In this method, color mixing is most effectively achieved by overlaying one color over another; and pictures painted in this way can contain enigmatic and luminous hues, unattainable with other methods and mediums. This method has since been practiced successfully by artists such as Turner and, in a more measured way, by the Pre-Raphaelites.

The opaque method

Many modernist techniques use opaque color, physically or optically mixed, to achieve a solid and immediate paint surface. However, the use of oil paint in a purely nontransparent way goes back to the Baroque period of the seventeenth century. A few painters, striving for a dramatic tonal effect, worked from a dark ground up into the lights, relying on the opacity of the paint film to provide the light effect within the composition. Others worked on a mid-to-light ground, establishing the dark first and then the lights.

If you're a relatively inexperienced oil painter, using opaque colors is a useful way of achieving chromatic and tonal unity across the surface. Because the paint is opaque, you can make revisions and work over it. Painting in solid color means that brushstrokes tend not to level out, allowing impasto and lively brushwork to be more evident. As you become more experienced, however, you may find that paintings made using opaque mixtures alone lack luminosity, becoming heavily laden when you are striving to create high tonal values.

End of terrace
Gerald A. Cains
Oil on canvas, 1977
36 x 24 in. (91 x 61cm)

Heavy impasto and solid opaque paint applications cover this painting and help to suggest a sense of solidity and tangibility.

The combined method

In practice, most painters combine the qualities of both transparent and opaque paint, often moving imperceptibly between the two. During the High Renaissance of the late fifteenth and early sixteenth centuries, an opaque underpainting was often enriched with many layers of rich glazes. A century later, the likes of Rubens would build up opaque body color over a transparent imprimatura ground (see Underpainting, page 53). The practice of combining deep, transparent shadows with opaque light masses continued as the standard method for painting flesh well into the late nineteenth century.

It takes skill and experience to move seamlessly between transparent and opaque methods within the same picture. It can also be difficult to judge the shifts in hue that occur between opaque and transparent mixtures, and to control their relative advancement across the painted surface.

Two oranges
Brian Gorst
Oil on canvas board, 1993
10 x 8 in. (25 x 20cm)

The wrapped orange was achieved in a single alla prima passage of opaque tones, while the other was glazed in stages, using yellows and reds.

TECHNIQUES 2 # Colored grounds

Using a colored ground is as common in oil painting as white paper is in watercolor. A colored ground can neutralize a complementary color that is applied transparently or thinly on top and enliven the same color when it is applied in broken strokes. The ground color can remain visible throughout a picture, unifying the surface, and its tonality can greatly reduce the time and effort needed to arrive at a certain value range.

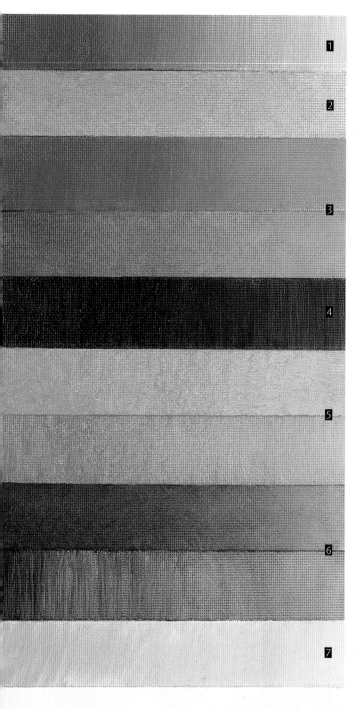

Colored grounds are almost always made by the artists themselves (see page 117). Traditionally, ground colors are moderate in intensity and value, relying on the low cost and reliability of the earth pigments. Listed below are some of the colors commonly used for grounds.

1 Gray The main function of a gray ground is to remove the glaring whiteness of the original ground. A light-toned gray is a multi-purpose ground that is useful for all genres of oil painting. It is particularly useful when you begin a painting with an open mind as to what the final color scheme will be. A mid- to dark-tone gray can be a little too dark for glazing, but it is suitable for most opaque application methods.

2 Terre Verte An earth-green ground was often used under areas of flesh by the Byzantine icon painters of the thirteenth and fourteenth centuries to neutralize the half tones of faces and figures. This is a highly sophisticated use of the ground, which allows the use of a simple warm, tonal palette of red, yellow, and white. It is only truly effective if the green ground is covered completely in all other areas of the picture.

3 Earth Red/Burnt Sienna Earth Red grounds are ideal for giving breadth and excitement to the green foliage colors in a landscape painting, while adding a subtle mauve hue to a sky and clouds painted over the top. A red/brown ground can also help to establish the warm shadow mass of a portrait or a figure painting, and was often used in the French figurative tradition by artists ranging from Poussin to Degas.

4 Dark brown or "bole" A bole ground is usually an opaque mixture of Earth Red or Mars Red pigments, mixed with black and a small quantity of Yellow Ocher. Dark brown or bole grounds were often used by such painters as Caravaggio and the younger Velázquez as a basis for dramatic chiaroscuro light effects with an opaque building-up of the light mass. The large shadow shapes found on figures in these types of compositions are often composed solely of the bare bole ground. Compositions are outlined in white or gray chalk. This type of ground is still used today by some portrait and figure painters.

5 Yellow Ocher/Raw Sienna The earth yellows provide a rich, warm ground without any great loss of luminosity. They are useful for painting landscapes or flesh, as in both subjects reds and greens can benefit from the presence of a warm, golden undertone. The paneled studies of Rubens show how a golden earth yellow, perhaps deepened with Burnt Umber, can give a seductive unity to the whole surface.

6 Burnt Umber/Raw Umber These two useful colors are both quick drying and semitransparent, which makes them ideal for applying to a white ground as a thin wash or imprimatura.

7 Off-white Cool, light greens and blues and warmer pinks and creams give good grounds for combined methods of application (see page 51). They allow skies, water, and atmospheric effects to be developed quickly using a mixture of glazing and opaque scumbles. Grounds of these high values are sometimes preferred by alla prima painters as a luminous base.

8 White A plain white ground is the most luminous ground for glazing. Its drawback is that it makes all applications of opaque paint appear darker by contrast. This may make the painter overcompensate and produce pale-looking compositions. The white ground found favor with many early Modernists, from Georges Seurat and André Derain, through to early Abstractionists, such as Mondrian, who appreciated the stark immediacy and luminosity of colors painted loosely upon it.

TECHNIQUES 3

Underpainting

The underpainting is one of the hidden facets of a traditional oil painting. Its main purpose is to allow the artist to work out the tonal values of a painting before addressing color and detail, and it is most useful in larger and complex pictures, where it can be difficult to maintain unity and order across the composition. Underpainting can also be invaluable when you are working within time constraints or when painting a subject in which accuracy in drawing is important, such as a portrait.

An underpainting may be the last stage in a series of preliminary sketches and studies (see page 46) or the point at which ideas are formed and compositions are born. There are a number of underpainting techniques.

HIGH-VALUE UNDERPAINTING
A high-value underpainting is used when glazes are to be applied. Often done in mixtures of white and black (or a faster-drying dark color) with no values lower than a midtone, the underpainting is rendered with full detail and subsequently glazed with transparent colors to give a full-value range.

TRANSPARENT IMPRIMATURA
Raw Umber or another semitransparent earth color is applied heavily to a white ground and wiped off in places to reveal a loose, tonal sketch. Imprimatura is used under a semi-opaque method of painting, where the luminous ground gives a richness to the darks.

OPAQUE, COLORED UNDERPAINTING
An opaque, colored underpainting is made in one color mixed with white. It can be painted in a full-value range of tones from light to dark, and subsequently overpainted with a full-color palette. For less experienced oil painters, this is the simplest form of underpainting.

LIMITED-COLOR INITIAL LAY-IN
With this method, the composition is sketched in thin paint in a few main colors. An initial lay-in is used to establish and test the light effect and color design before applying thicker and more finished passages of paint. It is often called the "dead coloring."

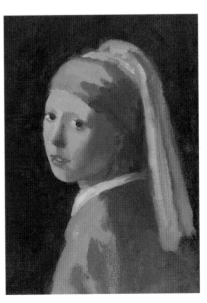

TECHNIQUES 4 # Fat over lean

The term "fat over lean" means that the ratio of oil binder to thinner is increased with each successive layer of wet over dry paint. It is important to understand fully the reasons behind this practice and to be aware of the many factors that influence it.

Oil paint dries through the chemical action of oxidization. After a number of hours, the outer surface will become tacky but the paint will still be movable. After one or more days, the paint will have gelled into a touch-dry film that can be overpainted but may be disturbed by increased abrasion or solvent action. After six months or more of drying, the paint will harden into a secure, resistant surface.

During these stages the paint layer fractionally expands and contracts. If faster-drying, leaner layers are applied on top of slower-drying oil-rich layers, they will adhere and form a dry, rigid film before the oil-rich underlayer has completed its movement, resulting in cracking of the lean layer within a year.

Factors affecting fat over lean

GROUND ABSORBENCY
When wet oil paint is applied to a surface, some of the oil is drawn into the ground. This is necessary to produce a secure bond, but if the ground is too absorbent too much oil will leave the paint and the surface may appear dull and the pigment poorly secured. There are ways of countering this effect (see Overcoming common difficulties, page 76), but they may involve using a richer medium than suggested by the fat-over-lean principle.

PIGMENTS
The amount of oil needed to turn different pigments into paint varies immensely and may affect its leanness. Oil-rich pigments include Alizarin Crimson, Burnt Umber, Cadmium Orange, Viridian, and Ivory and Lamp Black; the leaner, pigment-heavy colors include Yellow Ocher, Oxide of Chromium, Cadmium Red and Cadmium Yellow, Flake

and Titanium White, and most of the iron oxide-based brown-reds. Differences are more noticeable in higher-quality paint, as students' quality is often rich in oil and can sometimes be used without a binder.

MEDIUMS
Even if you monitor the amount of oil in the medium, mineral spirit used to clean brushes can easily find its way into paint mixtures, creating leaner and less secure layers. Conversely, during longer periods of painting, turpentine can slowly evaporate, leaving the medium too fat. You can judge the amount of oil in the painting's surface by its sheen. If the surface is too shiny, too much oil is being used and fresh paint will not adhere sufficiently. If it is matte and dull in the darker colors, and pigment can be brushed off, there may be too little oil (see Overcoming common difficulties, page 76).

PROCESS
Fat over lean could very well be coupled with the advice to paint "thick over thin," as a thinly spread layer will dry quicker than a heavily impasted one. An underpainting tends to be sparingly applied with thinned paint driven evenly across the surface using the stiffer bristle brushes, while subsequent layers consist of thicker paint smoothed and teased into place with softer brushes. In this way the underlayer will always dry before subsequent applications. By keeping the layers as thin as possible, through paint removal (see opposite), one can avoid an over-reliance on thinners that may weaken the paint film.

Fat and lean pigments

Pigment-heavy
Yellow Ocher

Oil-rich
Alizarin Crimson

Fat and thick paint consistency

Lean and thinned paint consistency

TECHNIQUES 5 Removing wet paint

Removing paint might seem to be at odds with the principles of painting and yet many of the greatest artists have systematically removed layers or sections of a picture. Sometimes this is done for practical reasons—for example, to reduce the thickness of the paint layer in order to paint fat over lean—and sometimes for artistic reasons. You should also never be afraid to obliterate an unsatisfactory passage.

RAGGING

Always keep a rag close at hand when painting. You can use it to remove whole passages of paint or to blend and diffuse an overworked section. By flicking a rag at an area, painters such as Degas would gently tease delineated marks into the masses. Ragging is frequently done in large-scale compositions. You should avoid exposing your hands to excessive amounts of certain pigments and solvents (see Health and safety, page 123).

TONKING

Named after the English painter Henry Tonks, this method is similar to placing blotting paper over wet ink. Simply put a sheet of newspaper or other thin paper over all or part of a wet oil painting, hold it firmly in place, and rub gently. The areas of thicker paint mass will transfer onto the paper, thus reducing the thickness of the wet paint layer. By using the end of a brush, you can reveal the dry underlayer or ground, contributing to the build-up of broken color effects.

SGRAFFITO

Scraping back paint with a knife or the end of a brush can produce a linear notation that has decorative and practical uses. Fine, flowing lines can be scraped back into the ground layer to create branches in landscapes, fine hair fibers in portraits, or occasional highlights. Such lines can evoke the decoration found on Ancient Greek vases and were used boldly in many works by Picasso.

SCRAPING

Thick areas of paint may have to be scraped back with a palette knife or scraper to return to the underlayers. Scraping can make the paint film on a canvas smoother and may produce unpredictable occurrences of broken color. Sometimes you may need to use a razor blade or craft knife to remove blobs of dried paint, hairs, or fluff trapped in the paint film.

TECHNIQUES 6 # Alla prima

Literally meaning "at the first [attempt]," alla prima is essentially a technique whereby a subject is painted in a direct manner during a single working session.

The term has also come to refer to an approach to picture making that is spontaneous, raw, and skillful. Painters such as Velázquez and Frans Hals incorporated alla prima passages in their paintings. It was the likes of John Constable and later the Impressionists, however, who became known for making oil paintings in a single session, sometimes with speed and bravura, at other times with carefully considered simplicity.

The materials

Most alla prima paintings tend to be, by necessity, on a small scale; and a colored ground may save much time and effort during the early stages. It can be useful to use a small range of familiar colors in order to avoid unwanted surprise combinations. As overpainting is minimal in alla prima painting, an oil-rich medium (perhaps the slow-drying poppy oil) and slow-drying pigments can extend the picture's practical workability.

The brushes

Large bristle brushes were used in this example initially to cover the broad areas quickly. A wide variety of shapes captured the different textures of the subject. Bristles were used in the early stages, as well as synthetic nylon brushes that replicate the spring of bristles. Nylon designer brushes were used for the detail in the flowers and jar.

The palette

The number of colors used was limited for speed and fluency. The palette has a cool bias to suit the cool nature of the colors in the main subject and background.

1 **Titanium White** was used for the highlights on the jar and to lift the brightness of the petals.

2 **Flake White** was employed in mixtures throughout the picture.

3 **Naples Yellow** was a warmer alternative to white in mixtures such as that used for the jar.

4 **Cadmium Yellow** was used as the general color of the flowers and also to make green.

5 **Lemon Yellow** is a cooler yellow and was used for the outer petals.

6 **Cadmium Red Light** gave the petals their rich inner glow.

7 **Cadmium Red** was included for balance but was little used.

8 **Indian Red** was a useful color for neutralizing the greens of the stalks in certain places.

9 **Burnt Umber** was mixed to paint the table edge and to achieve darks.

10 **Viridian** was useful as the main color in the stalks.

11 **French Ultramarine** was mixed with yellows and greens, and also added to darks.

12 **Cerulean Blue** was the basis for the background color.

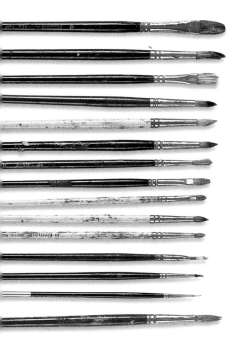

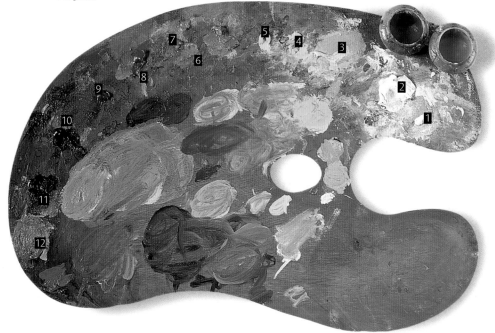

The process

Approach an alla prima painting with concentration and confidence—as if it is to be the last picture you paint. A loose underdrawing in charcoal or thinned paint will promote a freer, more open painting style. In the initial stages you should be aware of the main points of focus and think about whether some aspects of the subject can be simplified or removed. Locate the darkest and lightest areas and, if you are working wet into wet, aim to move gradually toward these extremes through the course of the painting.

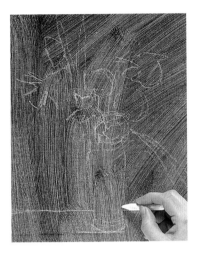

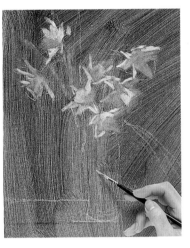

2 The key color and focal areas are laid-in with the yellows and Flake White. A thinner yellow indicates the location of the stalks.

1 The composition is drawn in white chalk over a ground colored with Raw Umber. Excess chalk is dusted off.

3 After the darker tones of the stalks have been placed behind the flowers, a generalized background color is applied sparingly with a bristle brush.

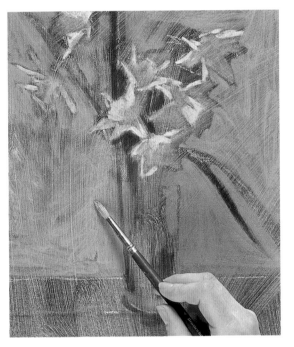

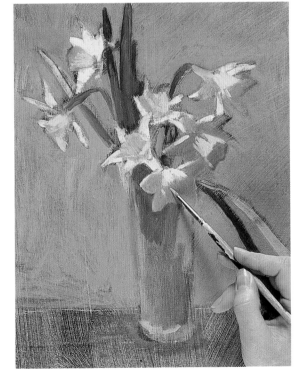

4 Detail and richness of color is added to the inner areas of the petals using quite thick paint.

5 The painted flowerheads are selectively tonked to reduce the paint thickness. This allows any overpainting and blending to be achieved more efficiently.

6 The darker toned shelf surface is painted to enable the artist to judge the overall composition and value range better.

7 More detail is placed around and behind the flowerheads, using darker tones. The green stalks are painted through the glass; the color is carefully chosen to emulate a submerged object.

8 The highlights on the vase are indicated in Titanium White. The translucent lights on the vase, which denote the border of the object, are also put in.

LEARN FROM THE MASTERS

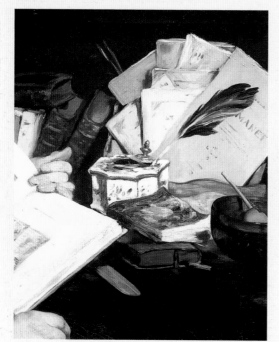

Portrait of Emile Zola (detail)
Edouard Manet
Oil on canvas
1867–68
44½ x 57½ in.
(114 x 146cm)

This detail clearly shows how Manet applied his paint in a direct and uncomplicated way using many opaque colors, sometimes tinted with white, in single-layer applications.

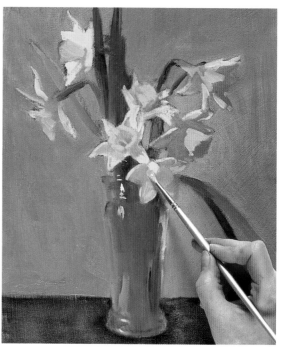

9 Further detail is added to the flower petals, paying particular attention to those in the central area of focus.

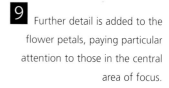

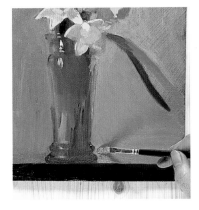

10 At this stage, in keeping with the spirit of the alla prima process, the artist lowers the level of the table. This involves removing the brown paint with a rag, lowering the background color, and altering the perspective of the vase base. The flower stems are substantiated in the vase with wet-into-wet applications of dark green.

11 Using the synthetic designer brush, the details of the flowers are carefully picked out. Painting such details during an alla prima painting may require the support of a mahl stick.

12 The glass highlights are painted in again, using a designer brush loaded with Titanium White.

13 With a few alterations to the long leaves (which previously exited at the top and side of the picture), this simple painting has been completed in about four hours. It can serve as a finished work or as a preliminary study for a more sustained and detailed composition.

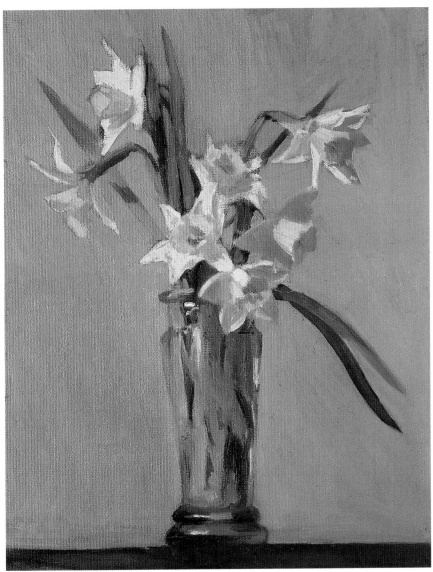

TECHNIQUES 7 # Wet into wet

To utilize the lingering wetness of oil paint is to get to the heart of what makes the medium unique and why it has dominated the artist's studio for over 500 years. The ability to blend one area into another and replicate the gently curving surfaces of faces, drapery, and other objects in full tone and rich color has arguably become easier over the last century as the range and strength of pigments has increased.

The materials

A wet-into-wet technique may be easier with a little more viscosity in the medium, and so the addition of stand oil or Venice turpentine will help. Smoother surfaces, such as panel, hardboard, or metal, will make blending simpler to achieve.

The brushes

In this painting, two quite soft bristles were used to transfer large amounts of paint quickly to the broad areas; rounds were suitable here as they are good for blending and do not leave sharp-edged strokes. Sables were used to bring the paint to a finish, and included a long, thin rigger for the stalks. A fan brush was used "dry" to blend subtle tones across the background.

The palette

The semitonal arrangement of paints in this warm/cool palette has been dictated by the color of the subject. The greens are to be either complemented or muted by the warmer yellows, red, and brown.

1 **Flake White** proved too subtle and was little used.

2 **Titanium White** was useful in achieving the soft highlights.

3 **Naples Yellow** provided a warmer alternative in the light mass.

4 **Cadmium Green** emerged as the key color on the palette, mixing well into the light mass and half tones.

5 **Sap Green (lightfast mixture)** is a transparent, warm green that was useful in linking light mass with shadow mass.

6 **Cobalt Green** is a good, semi-opaque color that was used to bring coolness to the shadow and half tones.

7 **Phthalo Green (yellow shade)** helped to give depth to the shadow mass; mixing well with Burnt Umber.

8 **Phthalo Green** was a little too cool and intense on its own, but it helped to achieve the background and the darkest clefts of shadow.

9 **Premixed gray** formed the opaque body color of the background and table top.

10 **Cadmium Yellow** helped to extend the warmth of the Cadmium Green.

11 **Yellow Ocher** kept the stronger colors in check as it related the paint layer to the ground color.

12 **Flesh Ocher** is an opaque iron oxide that was used both to neutralize the green in the pear and to build up the shelf top.

13 **Burnt Umber** mixed well with all the greens to darken and warm them. It formed the basis of all the darks underneath the pears and in the background.

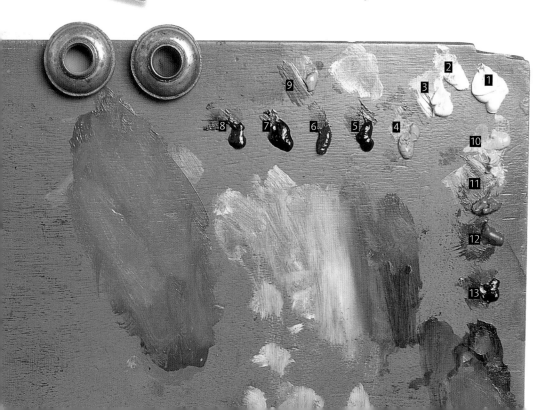

The process

As with the alla prima approach, wet-into-wet painting is completed in one sitting, producing a single homogeneous paint layer, but the objective here is a more naturalistic and less painterly finish. The artist needs to work swiftly and with confidence, employing a variety of strokes and applications—in some areas flat and opaque, as in the background, while in others stippled and broken, as in the fruit. This would be an ideal technique to apply to a subject that the painter was familiar with and had previously explored in a more labored manner. The medium can be fairly oil-rich as the single paint layer will need to form a secure surface that can survive the effects of varnishing, cleaning, and age.

1 Around an hour is spent arranging the fruit, the light, and the surroundings. Then the general outline is sketched in vaguely using charcoal. The forms of the fruit can be overemphasized at this stage so that successive applications do not whittle away their character too early.

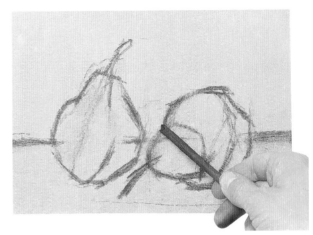

2 After dusting off the charcoal until a pale line remains, the light mass is painted in using large bristle brushes loaded with paint. (There is no need here to thin out the paint because the overpainting will merge fully into this layer.)

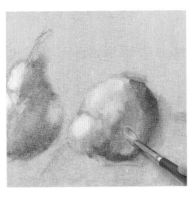

4 The general masses of the background and shelf are laid in to help achieve a rough idea of how the picture might look, but are kept vague enough to allow for later modifications.

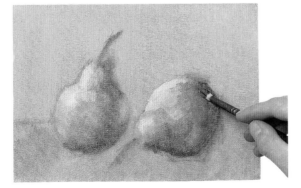

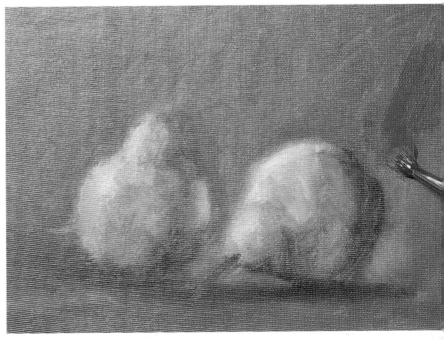

3 The shadow mass is applied in a similar way with a fresh brush. The attention is on the body of the fruit rather than on the outline. The half tones and the turning of the shadow are filled in using the same brushes with slightly different colors, dragging the light and shadow together to produce two solid, if blurry, forms.

5 Here the picture is tonked, removing unwanted mass in the paint film and reintroducing the ground color across the picture surface. At this stage the back edge of the shelf is repainted lower and the pears are shifted closer together. Then the forms are "firmed up" and the edges are made more distinct using the larger sable brushes. From this point onward the objective is to refine the surface and outline of the pears gradually while maintaining freshness of color and strength of tone.

6 Both the highlights (left) and the deep shadows (above) have to be reinforced when the paint becomes a little muddy. In the small shadows beneath the pears this is achieved by painting with a loaded sable over the previous layer in a way that will not disturb it.

7 A large amount of background color is mixed with the knife on the palette (enough to avoid having to remix exactly the same combination again). This is applied with a large sable and smoothed out using a fan brush.

8 It is at this point that the final edge of the fruit is defined. The same technique is used for the shelf top.

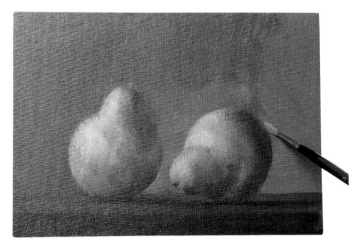

9 The stalk is painted in single loaded strokes and the painting is assessed for any loose ends. In this case the edges of the pears are too crisp against the background, so they are blurred slightly using a small dry sable.

10 The finished painting shows how the color and luminosity of the ground play an active role within an economical process. In this case the high value of the ground helps to achieve the inner glow of fruits with pale centers and translucent skins, and its color unifies the picture surface.

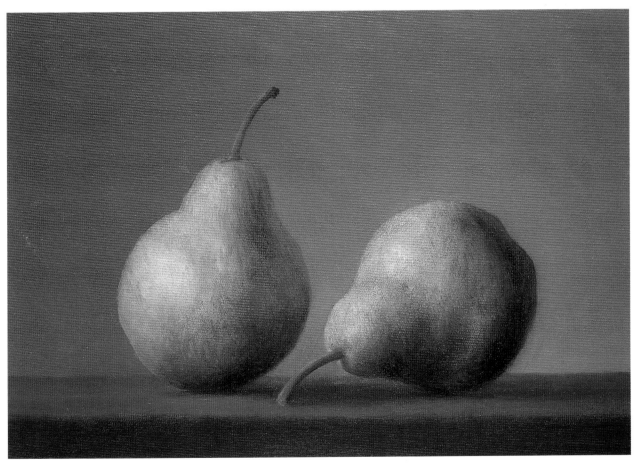

TECHNIQUES 8 # Broken color

Broken color describes optical mixing effects that occur between applied strokes and exposed underpainting. Less ordered than pointillism, broken color is an intuitive method of paint application that goes back to Titian and is at the heart of impressionist techniques. Broken-color effects are often achieved by scumbling (dragging opaque paint over a dry and sometimes textured underpainting); they can also be created by applying single, unmixed dabs of paint loosely wet on wet.

Scumbling is an effective way of depicting textured surfaces such as brick, earth, sea, and foliage, and painters such as Lucien Freud have successfully used such brushwork to render the human figure. The visceral nature of scumbles and broken color is well suited to the freedom and gesture associated with abstract expressionist techniques, where the ability to utilize accidental and unplanned marks is important.

The materials

Coarse- or medium-textured canvas helps to diffuse brushstrokes and highlight scumbles. Sometimes unfinished canvases can be reused successfully, the older layers deliberately left to show through. A board or panel will provide a firmer support if you intend to scrape back into the paint layers using a palette knife. Grounds that play a role in a broken color scheme tend to be strong and toned in color. In this picture very little medium was needed, as paint was largely used in its tube consistency.

The brushes

Bristle brushes were used here throughout, as their hardwearing nature is suited to scumbled brushwork on a textured ground. Older, more out-of-condition brushes can add variety to the marks. Filberts and flats of varying sizes were used, progressing from large to small as the painting moved into detail.

The palette

The palette was laid out with fairly cool and limited prismatic colors.

1 **Titanium White** was used to provide a cool and opaque white that would capture the luminosity of snow and maintain its integrity in scumbles and mixtures.

2 **Cadmium Yellow** was used only in a mixture with white.

3 **Raw Sienna** was used only in a mixture in the far distance.

4 **Burnt Sienna** was mixed with ultramarine for initial underdrawing and tree trunks.

5 **Alizarin Crimson** was laid out for possible violet mixes but was unused.

6 **French Ultramarine** was used as an alternative to black in the darks, often mixed with Burnt Sienna.

7 **Cerulean Blue** was the most prominent color after white, providing cast shadows.

8 **Viridian** was used to add a green edge to the snow, hinting at grass beneath, and also to achieve some darks.

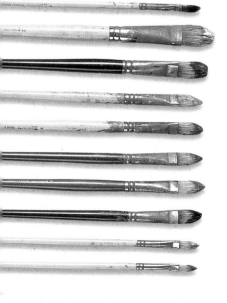

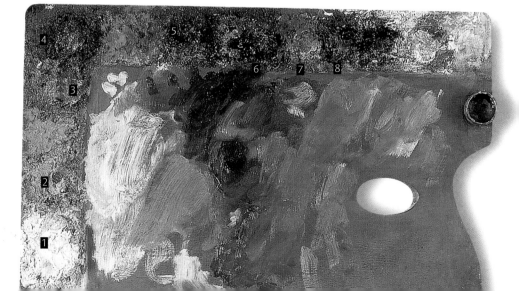

The process

Stiff and well-used bristle brushes will break up the paint surface; place the brushstrokes in a variety of directions to prevent them from looking too mannered. Hold the brush at a raked angle, in a similar way to the use of chalk pastels on textured paper, to make it scumble more effectively. Bright, opaque colors, such as cadmiums and tints with white, keep their integrity when broken by the surface.

1 A canvas-covered board is primed and covered with a Burnt Umber ground. The snowy scene is sketched onto the dry ground using a thinned, dark color and excess paint is removed.

2 The main light effect is captured early on in white. A large brush is held at a shallow angle to pick out the texture of the canvas and so represent the appearance of snow on ground.

3 Cadmium Yellow is added to the white in areas to capture the reflection of the rising sun. The main area of neutral green background is placed between the trees.

4 The striated shadow shapes are painted in a cool midtone opaque blue, using a large flat brush on its flat and edged side.

5 Distant tree trunks and shapes are described with a smaller brush in blues and greens of muted hues and a limited tonal range.

6 The branches of the nearer trees are painted to contrast against the sky, using the sensuous line qualities of the filbert brush. Good observational skills and an experience of the subject are important when depicting recognizable objects such as trees.

7 Snow is painted on the top of the branches, using a fresh loaded brush to place the paint without disturbing the wet branches. These notes of white add tonal variety to the upper fifth of the painting and help the branches to stand out.

8 Patches of warm brown are loosely scumbled into the snow and among the branches. This is in response to the subtle changes in the scene that took place during the session and to avoid the picture becoming too cool. Green is also added to small areas.

9 The cycle tracks are driven through the wet paint in single brave strokes, creating an area of semiblended paint amidst a mass of scumbling. These marks add a human element to the theme and help draw the eye through the composition.

10 Small marks are placed in the far background to create a loosely architectural motif. On the whole, details of this kind have been kept vague in favor of the overall light effect.

LEARN FROM THE MASTERS

***Christmas night (The blessing of the oxen)* (detail)**
Paul Gauguin
Oil on canvas, 1896
38½ x 28 in. (98 x 71cm)

Gauguin, who had exhibited with the Impressionists early in his career, has here used the rough herringbone weave of his canvas to break the paint strokes and enforce optical color relationships.

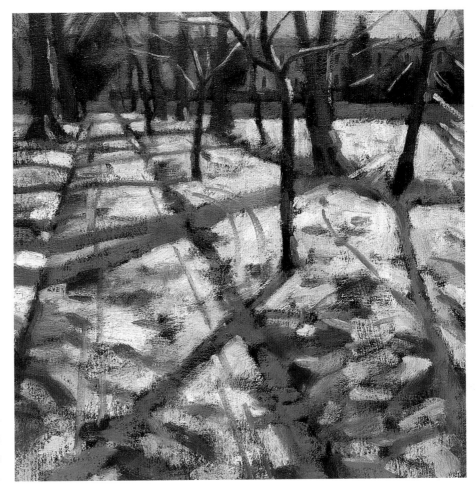

11 The finished picture is an alla prima study, painted out of doors, which attempts to capture a fleeting and constantly changing subject. The various marks of the snow, ground, and trees have required full use of the scumbled paint and canvas texture.

Glazing

When transparent glazes are applied over a luminous ground, the resulting colors can far exceed opaque layers in richness and charm, and have proved to maintain these qualities over time.

Glazing can be used across the entire surface of a painting or in selected areas where a certain brightness or richness is required. You can use a single layer in various strengths or multiple layers to depict the local color of an object; alternatively, overlay a number of colors to achieve vibrant combinations. Glazes are also useful in the final stages of an opaque painting, as they can be used to shift the hue or tonal value of particular areas to unify the composition.

The materials

All glazing colors must be at least semitransparent. As few as three primaries can be used, and white must be excluded. Many earth colors are too muted to use as glazes; conversely, phthalo- and quinacridone-based pigments can be unsubtle. Glazing mediums have to be thicker than usual, with good adhesion and leveling properties. Resins such as Venice turpentine are often added to the medium, as is linseed stand oil. Liquin may provide a quicker-drying glazing medium if the ground and underpainting are dry and relatively oil free (see Mediums, pages 16–17). Use a pale palette to judge the translucency of the paint better. Avoid textured canvas, as glazes tend to gather within the weave and emphasize the surface.

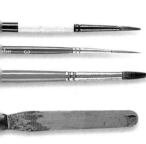

The brushes

Sables and fine nylon brushes were needed here to produce even layers. One long-handled nylon brush was used for large amounts of the painting, with a designer brush and a rigger for the details. A blending brush helped to achieve the sheen on the table surface.

The process

Glazes should be applied on top of an accurate and pale underdrawing. Layers of glaze can be applied in a number of ways, ranging from thin scumbles pushed into the ground to rich strokes laid on the surface. Use a lint-free cloth or dry brush to wipe off the glaze as a quick method of achieving lights. Although you can do a lot of blending and tonal variation in a single session, it is a common rule of all painting that two thin layers are more reliable than one thick layer. Always leave a glaze to dry for at least a week before applying any subsequent layer and follow the principles of fat over lean (see page 54). In common with watercolor and printing processes, the lights and the yellows tend to be applied first, with the darker and blue/violet hues overlaid last.

The palette

Very few colors were used for this fairly monochromatic subject and orange was deliberately avoided in favor of combinations of red and yellow.

1 **Lemon Yellow** was used to provide a slightly cooler yellow area in the light mass.

2 **Perylene Red** is a full red similar to Cadmium Red Deep, but with a transparency that makes it ideal as a glazing color.

3 **Alizarin Crimson** was used to add depth and richness to the shadow mass.

4 **Burnt Umber** is a useful orange-red brown, employed here in the shadow mass and in the background.

5 **French Ultramarine** was used only as a background color, premixed with Burnt Umber.

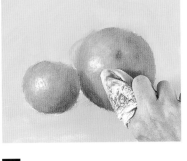

1 The composition is drawn carefully onto thin paper the same size as the canvas. The outline and major shadow shapes are pricked with a series of holes through which charcoal is rubbed on to the canvas. Excess charcoal is brushed off, leaving a faint outline that will not be seen through subsequent layers. An underpainting is applied in yellow, covering all areas that appear warm in the subject. (In this case the underpainting was painted in Lemon Yellow acrylic on an acrylic-primed cotton canvas, allowing the application of subsequent layers after a few hours.)

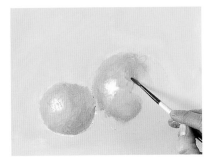

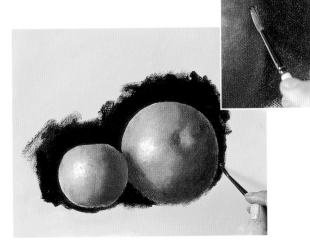

2 Glazes of red and yellow are applied both singly and blended. The darker colors are employed in the shadow mass.

3 While the paint is still wet, some areas of the light mass are lightened by removing the glazes with a cloth.

4 After a week of drying, the deeper tones of the orange are overlaid using Alizarin Crimson and Burnt Umber. It is important to apply the paint smoothly, without excessive agitation, as at this stage the underglazes can still be disturbed. The background is painted around the oranges in order to judge the relative depth of the shadows. Careful attention is paid to the edge of the form, where subtle blending of background and object can help achieve an illusion of depth.

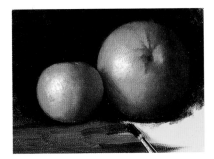

5 The table top is painted in alla prima fashion, with the reflections applied into the wet paint and blended with a blending brush.

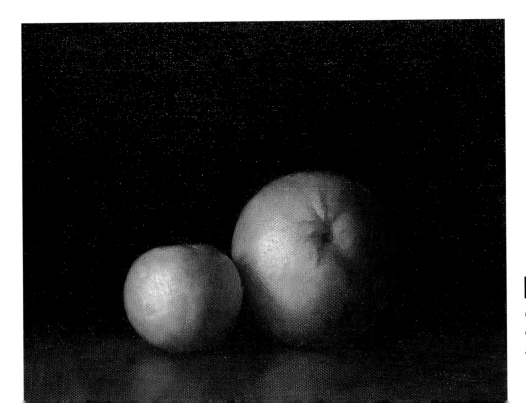

6 With the background completed to the edge of the canvas, the oranges finally emerge as the center of focus.

TECHNIQUES 10 # Pointillism

In its pure state, pointillism, or "divisionism," is a formalized method of mixing color by carefully placing blobs of full-strength paint next to one another so that they combine in the air between picture and eye. The term is also used in a more general way to describe the use of colored dots as a decorative device, creating a notational uniformity similar to that found in mosaic or tapestry, often adding excitement and life to the painted surface. The Neo-Impressionist, Georges Seurat, is famous as a pioneer of pointillism and his highly developed and classicist compositions reflect the analytical state of mind needed to execute pointillism proper. Many artists, however, combine true pointillism with a looser, more impressionistic approach.

The materials

Although traditionally painted on a white ground, you can save time by underpainting pointillist pictures in bright colors, possibly contrasting to the subjects painted. If you do so, use a palette with a color similar to the painted surface. You may need a mahl stick to support the hand during sustained periods of work. In this painting, the use of liquin as a medium allowed repainting the following day.

The brushes

Around six short-handled brushes were used for this painting, all of a similar size to achieve a similarity of dot width. The brush fibers were nylon or synthetic/sable blends. Rounds and small flat brushes gave subtly different notations. A few riggers were also used, as they can produce slightly smaller dots and have fairly good paint-holding capacity.

The process

Apply dots wet over dry, using little medium. You may need to clean brushes more often than usual. Ensure that neighboring dots of different hues are of similar tonal value; colors should spill over the edges of objects, infusing the surface with their presence. Do not blend or merge dots, as this reduces the effect. The size of the dots depends on the scale of the picture and the distance from which it is to be viewed, but should be consistent throughout the picture.

The palette

The paints were laid out in a warm/cool configuration and tinted mixtures of each color were premixed to provide a two-tier full-color palette.

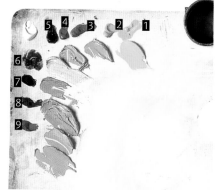

3 Cadmium Red is a warm solid red able to work against the strength of the ground color in mixtures.

4 Perylene Red has a transparency that made it useful in brown mixtures for the hair and as a subtle neutralizer for greens.

5 Alizarin Crimson was used mixed with white in the lighter tints and as a rich dark for the hair.

6 Cobalt Violet was used infrequently; tinted to a mid-tone in the green jacket.

7 French Ultramarine was used in a variety of values for mixtures and for the first passage of the jacket.

8 Cobalt Blue was little used except in some of the green mixtures.

9 Permanent Green Light is a phthalo-derived paint that was used as a timesaver in the building-up of the green jacket.

1 Lemon Yellow was used as a cool yellow in mixtures, and as a semitransparent yellow in the darks.

2 Cadmium Yellow is a warm yellow that was used here unmixed and mixed throughout, particularly in the greens.

1 A blue-green colored ground is prepared as a strong complementary to the red-orange of the flesh, and the portrait is carefully transferred from a measured drawing. Small dots are applied swiftly across the surface, starting with the main area of focus.

2 All areas of the picture are tackled in their respective values right from the start in order to establish the scheme of the picture and to diminish the strength of the ground color quickly.

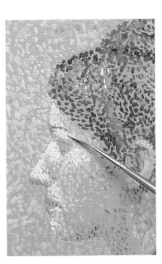

3 Yellow is added to the previously placed pink in the face to create an optically produced orange that is neutralized into a flesh color by the ground. (Two analogous colors are often used in this way to create the hue found between them on the color wheel. See pages 36–37.)

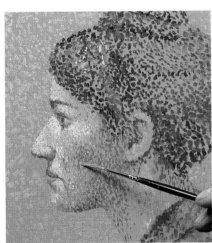

4 Tonal variation is achieved in the half tones of the face by lowering the value of the colored dots at the same rate across the plane. Details such as the eyes and lips are applied with slightly smaller dots, and the green jacket is begun with a series of bold blue dots.

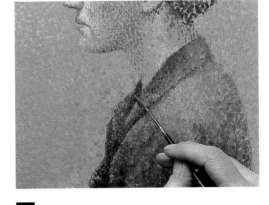

5 The background is covered with dots of a second color and the green jacket is painted in a mixture of yellow, blue, green, and red dots. The dots become partially blended in the lightest area; toward the edge of the picture they are allowed to become larger and more casually arranged.

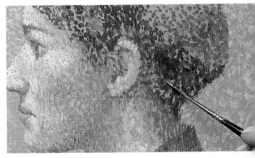

6 The ground color is gradually painted over in all the areas of the painting that remain untouched. The neck is treated in a similar way to the face and the hair is painted in a series of darker dots, the light ground color being more purposefully covered here than in the face.

7 A pale blue color is applied to the background in order to neutralize the entire area. Although applying a less than pure color in rather large dots departs somewhat from the pure "divisionism" that Seurat may have used, it seemed necessary in this case to enforce a separation of subject from background.

8 After a few minor adjustments and the addition of detail, the picture is completed. The pointillist method means that this portrait exhibits different characteristics when viewed at different distances, the dots of color separating when close and merging into a whole when seen from farther away.

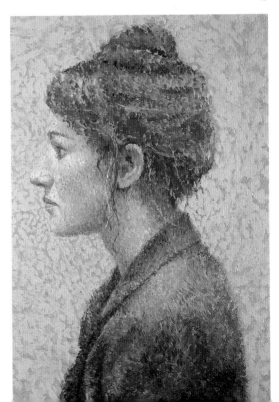

TECHNIQUES 11 # Impasto

Impasto describes a build-up of paint on the surface that is thick enough to have a function beyond that of its color. In many respects, this is in opposition to the principles of illusionistic form (see page 28) and is often a result of more modernist approaches to picture-making. Heavily impastoed paint tends to draw the eye to the surface of the picture and to its own tangibility. This can be seen clearly in the gestural nature of de Kooning's work or in the heavily loaded brushwork of Frank Auerbach.

There are, however, more subtle uses of impasto. Van Gogh used consistent, heavily drawn brushstrokes to guide the eye both across and into his compositions, producing an effect of immediacy and realism. Impasto is used atmospherically to aid the effects of broken colored scumbles in pictures such as Monet's Rouen Cathedral series. A more traditional use of impasto is in the building-up of opacity in the light mass when using a semi-opaque color or Lead White, as in the portraits of Rembrandt or the flower paintings of Fantin-Latour.

The materials and process

To a large extent, the use of impasto is intuitive and unplanned, but there are ways to increase the likelihood of certain effects occurring. Oil paint tends to level out as it dries, and so it can be bulked out with inert substances, such as wax, gel mediums, sand, or sawdust. In this painting, liquin was used as a medium to give body to the paint without increasing drying time. Various brushes contribute in different ways to the impasto effect, and a painting knife produces a solid, flat mass of overlapping hard-edged waves. It is sensible to use cheaper paints for experimentation; the alkyd range of quick-drying paints has proved very efficient in thicker applications.

The palette

A brighter palette of opaque colors suited this subject, and these were quite casually laid out as and when they were needed.

7 Ivory Black was used for its ability to produce grays and shades quickly in thick mixtures.

8 Raw Umber was mixed with blue tints for the distant hill, and used in mixtures for the horses.

9 Cadmium Red was another color used for the jockeys' silks and mixed for the horses. It can also be found in the grass at the foot of the picture.

1 Titanium White was used extra-stiff to bulk out the mixtures and produce strong tints.

2 Permanent Green Light is a phthalo-derived paint that is bright and a good mixer.

3 Cadmium Lemon Yellow was used in mixtures and on its own in the distant flag.

4 Cobalt Blue was used throughout in many mixtures. It can be mixed toward both violet and green hues.

5 Pthalo Green (yellow shade) is a darker yellow-green color.

6 Premixed Pink was used for the jockeys' silks and mixed for the faces.

The brushes

Filberts and flats were chosen for most of the brushwork for their variety of mark-making, but most of the paint was applied using a painting knife. This achieved the desired impasto effect and allowed for easy removal and scraping of the paint surface.

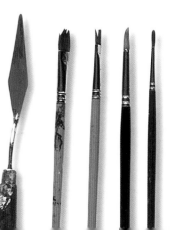

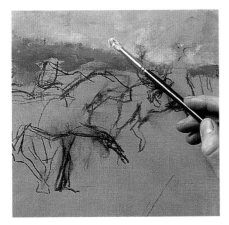

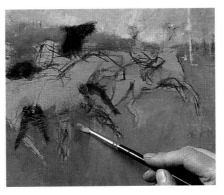

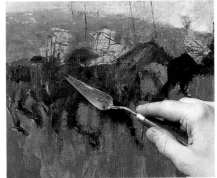

1 On a neutral gray ground the composition is sketched in freehand and the distant landscape is painted using brushes. This will be the least impastoed area of the picture, which should help to keep it visually behind the foreground.

2 The gray ground is quickly covered and the grass painted over thinly in order to allow the painter to assess the composition better.

3 The color of the horses is laid down using a painting knife and brush in combination. The underdrawing is obscured and the painter makes minor alterations to the legs of the horses.

4 Brighter colors are applied to represent the silks of the riders. At this stage the painter tries out various color combinations and removes certain knife strokes of paint that do not seem to work. The process is similar to that followed by the abstract painter, and the lack of detail here will be in the spirit of the fast-moving subject.

5 The grass is applied freely with the knife in two or three colors semimixed on the surface. The knife point is used to add a sgraffito texture in the foreground. Small dots of red break the monotony of the green.

6 Details such as the horses' legs and riders' faces are completed with a brush. A yellow flag is placed in the sky to bring a color note to the right-hand side of the composition.

7 The finished picture has a moderately impastoed surface that adds to the sense of movement and excitement in the scene, and brings the horses and the racing ground forward of the sky and hills. Details are sacrificed in favor of the spontaneity of the whole.

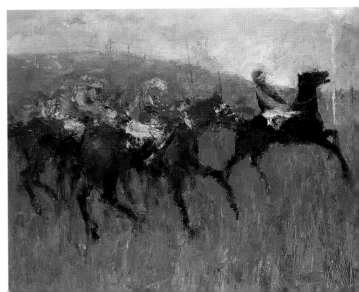

Mixed media

Oil has an earthy, physical presence and can contrast or combine well with a range of other materials. Artists such as Anselm Kiefer and Julian Schnabel infuse and adorn large oil canvases with many different organic and inorganic materials for aesthetic, symbolic, or ironic effect. On a smaller scale, many painters have used sand, wood chips, string, and other substances to alter the mass of the medium and have even extended the painted surface onto another surface, such as the picture frame, or outward into a raised surface similar to shallow relief.

The materials and process

Different materials can change the way light reflects off the surface of an oil painting, contrasting with the smooth surface of oil used alone. Mixed media can also introduce directional marks across the surface in addition to those made by the brush. Materials such as card and wood are best included within the ground layer, while looser materials, such as sand, leaves, wood chips, feathers, or newspaper, can be mixed or applied with the paint, using its properties of adhesion, and left to dry with the picture flat. Other uses of mixed media include an Indian ink or watercolor underdrawing or an egg tempera or acrylic underpainting. Paint sticks are a recent development allowing drawn marks to be made over wet or dry paint. These oil-based drawing tools come in various colors and are very compatible with oil paint.

The palette

In keeping with the traditional Cubist theme of the painting, a simple earth palette was employed.

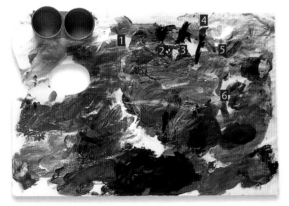

1 **Cadmium Red** was used sparingly to warm up the browns.

2 **Burnt Umber** was mixed to form light and dark browns, and was used transparently to stain the newspaper and burlap.

3 **Ivory Black** was used to neutralize, build up grays, and outline separate forms.

4 **Cerulean Blue** was employed in the grays and the napkin.

5 **Flake White** was used throughout in mixtures and on its own for the napkin.

6 **Raw Sienna** gave the limited palette all the yellow it needed in mixtures with white and other colors.

The brushes

Various brushes of differing sizes were used, and a palette knife was employed in the application of the mixed media. Burlap, scrim, and newspaper were added to the surface using an acrylic medium as a quick-drying adhesive.

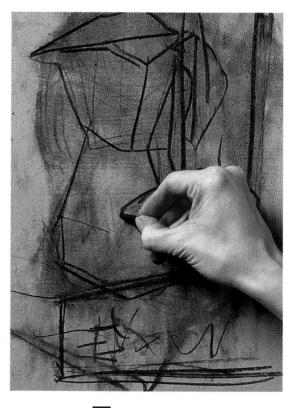

1 The composition is sketched freehand on an acrylic-based gray ground.

2 The acrylic medium is thickly applied onto the surface and the scrim is pasted in the appropriate place. (A mixture of gently heated wax and genuine turpentine can be used in place of an acrylic medium.)

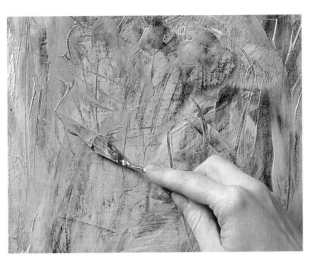

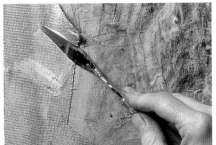

3 The newspaper and burlap are also embedded into the wet medium and smoothed out with the palette knife. The panel is then left to dry out completely for a few hours.

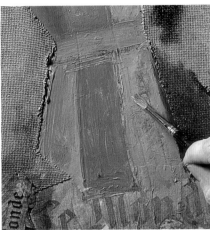

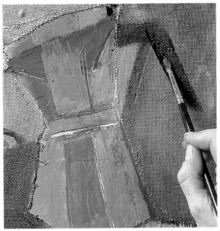

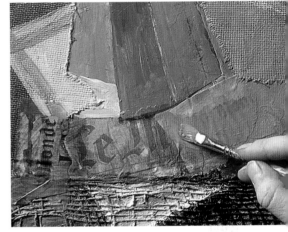

4 The general shapes are painted in with oils and the mixed media is painted over to better integrate it into the composition.

5 Alterations to the composition are painted in and the forms are made more distinct.

6 Features such as the napkin and the croissant are added to bring variety and color to the painting.

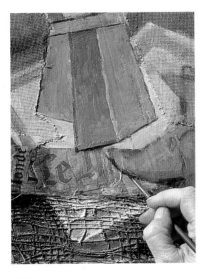

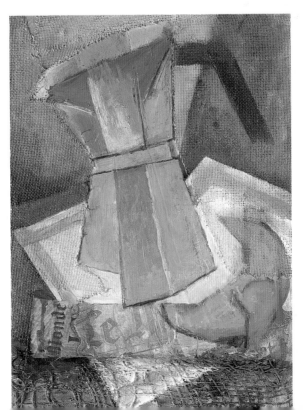

7 The edges are tidied up and broad areas, such as the background, are smoothed out.

8 The finished picture is a simple, invented still life, combining mixed-media processes and Cubist-style drawing.

Overcoming common difficulties

Oil paint is often perceived to be a difficult medium and yet most of the difficulties experienced by students have simple solutions. Here are some common difficulties followed by possible causes and solutions.

The brioche (detail)
Jean-Siméon Chardin
Oil on canvas, 1763
22 x 18½ in.
(56 x 47cm)

The evenly distributed cracks here suggest movement in the layers of the picture rather than impact damage, which tends to result in concentric cracks.

PICTURE TAKES TOO LONG TO DRY

If the medium used to build up the paint is oil-rich or applied thickly, it will take longer to dry than a thinner and leaner layer (see Fat over lean, page 54). Painting on metal or highly unabsorbent grounds may also extend the drying time. If the atmosphere is cool or damp, or if the picture is covered over or enclosed, the chemical process of oxidization will be retarded. Adding a cobalt drying agent to the medium is not recommended, as this may increase the risk of cracking, but liquin can be effectively used in the early stages of a picture. Certain manufacturers of artist-quality paint add drying agents as standard (see the manufacturer's own information or labeling). Use quicker-drying pigments and paint in thin and lean layers on an absorbent ground, such as sanded acrylic gesso on board.

PICTURE DRIES TOO RAPIDLY

This is often a problem when working out of doors in good weather, as paint may dry on the canvas and palette before sufficient reworking has occurred. Adding a little more oil (such as poppy, safflower, or sunflower oil) to the medium will slow down the drying time. Storing a canvas in a cool, damp place or covering it with plastic will keep a painting fresh for the next day, and a single drop of clove oil can keep a blob of paint active on the palette for a few days.

PICTURE DRIES UNEVENLY

If separate passages of paint dry at different rates, the cause is probably an inconsistency in the drying times of different pigments or a change in the constitution of the medium. If the variation is random across the painted surface, the cause is more likely to be either moisture settling on the surface prior to underpainting or an inconsistency in the ground or size application. Always ensure that primer is sufficiently smooth, that size is the right consistency, and that both are evenly applied. Also examine carefully the surface of premade stretchers for evenness and quality of ground.

DRIED SURFACE IS MATTE AND LIFELESS

The dulling of the paint upon drying is a very common difficulty for painters and is usually caused by too little oil in the paint film—either due to absorption into the ground layer or through overuse of thinners during painting. This can be remedied by a process known as oiling out, which involves rubbing linseed oil sparingly into the area to be painted at the beginning of a painting session so as to regain its luster. A damar and white spirit retouching varnish can also be used in moderation, as can a 50:50 mixture of mineral (white) spirit and stand oil. Traditional oil grounds are less likely

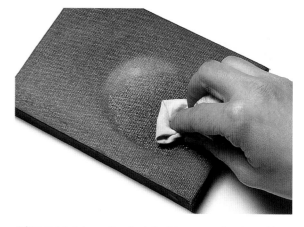

Oiling out a picture will make dull paint appear wet again, and is necessary for accurate color matching of overpainted layers.

to draw the oil out of the paint than modern Titanium White acrylic grounds. It is said that artists of the past would polish a painting with a piece of fine silk to bring luster back into the surface.

PICTURE HAS AN OILY WETNESS AFTER GLAZING

This seems to have been a recurring problem since the fifteenth century and is mostly due to heavier pigment particles settling lower in the paint film of an oil-rich glaze, leaving a surplus of oil on the surface. To counteract this, carefully blot off the surplus oil with tissue paper without altering the pigmented layer (this may even dry before the oil above it). Adding resins or stand oil to the glazing medium to make it stiffer and more viscous, and using thinner glazes, will also help to prevent the problem.

PAINT WILL NOT ADHERE TO THE PICTURE SURFACE

Using too much oil or varnish in the medium can prevent subsequent layers from adhering to the picture surface. The presence of moisture or dampness on the surface or in the atmosphere can also contribute to this problem. If the paint is dry, lightly scuff the surface with some fine glass paper so that it regains its absorbency. A thin application of retouching varnish can help adherence of subsequent layers, but the simplest solution is to paint from the start in leaner, thinner, and fewer layers.

PAINT LAYER IS TOO THICK

Thick paint consistency and an uncontrolled style of application can create a thick paint layer that can become heavy and unmanageable. The simplest way of keeping paint layers thin without compromising the strength and flexibility of the film is to reduce the paint thickness through tonking (see Removing wet paint, page 55). You can also try using a little more thinner in the medium or working on a rougher, more absorbent ground. If you have a tendency to apply the paint heavily, using a larger canvas may help.

COLORS ARE MUDDY AND DULL

This is the most common complaint of novice oil painters. The problem is due to overmixing the paint on the palette or overblending on the picture surface and can be a sign that the painter is enjoying the texture of the medium. By using no more than two or three pigments in any mixture on the palette, and by placing unmixed and unblended paint on the canvas from time to time, brighter colors will emerge.

COLORS TAKE TOO LONG TO MIX

An inability to mix the right color quickly can be frustrating, resulting in much wasted paint and an interrupted creative flow. This may be due to a poor understanding of basic color theory (see pages 34–39) or the use of an overcomplex or inadequate palette. You can achieve a better understanding of color mixing by using a limited triadic palette of the primaries (red, yellow, and blue), which provides a simple yet comprehensive range of color combinations. Students can gain much understanding of the behavior of color by creating their own color wheel using the primaries.

INABILITY TO MATCH COLORS SEEN IN THE REAL WORLD

This is a common and understandable concern for the novice oil painter, who may be expecting too much of the medium. Many subjects are too intense and luminous to be reproduced accurately in any painted medium and you have to accept the fact that a painting needs only to work within its own value and color range to be successful. It can be helpful to place your picture away from the subject when painting to avoid unhelpful comparison. Frequent study in galleries will help you tune your eye to the relatively restrained values and saturation used by the past masters.

The artist used thick applications of paint when creating this picture yet kept control of the surface through selective tonking.

Sunlight in Rodin's house
Peter Kelly
Oil on canvas, 2002
17 x 21 in. (43 x 53cm)

CHAPTER 4

Exploring themes

Oil painting emerged at a time when subjects and themes were chosen through religious, civic, or private patronage. Painters had to exercise their personality and subjectivity in subtle and discreet ways. Nowadays, artists have complete liberty in their choice of subject matter and are able to source myriad reproductions and references and to travel to almost any location in the world. You do not even have to restrict yourself to observing and painting reality; dreamlike compositions, surreal juxtapositions, and abstracted forms have all become exciting modes of exploration, and the reworkability of oil paint is particularly suited to pursuits of this kind.

This chapter examines a number of different themes, from still life and landscape to portraiture, abstraction, and works painted entirely from the imagination. It can be stimulating to shift between these genres, applying similar methods and styles to each. Although painters sometimes work on a number of themes simultaneously, it is more common for them to ease gradually from one subject into another, responding to their artistic impulse. Great artists from Leonardo da Vinci to Picasso have drifted through many themes, subjects, and motifs throughout their illustrious careers, drawing inspiration from the historical, observed, and imagined world. This chapter offers insight into a wide range of themes in the hope that you will become inspired to try out ways of working that you may not have previously considered.

THEMES 1 # Still life

Only rarely in its 400-year history has still-life painting been the most popular choice amongst patrons, collectors, or the public, yet it has attracted the creative efforts of many of the great masters of art. This may be due to the absolute control that the painter has over the subject, enabling bold and progressive exploration.

Often the artist will favor a sparsity of subject, with a single light source illuminating the objects in their raw and rested state. Sometimes a still life will have a symbolic meaning, perhaps revealing a narrative; at other times the subject is domestically located, inferring a human presence beyond the picture's border.

Still life can serve all approaches and techniques, from the highly detailed tradition of the Dutch Baroque to the cubist papier collé (stuck paper) compositions of Braque and Picasso. It requires the minimum of studio space and materials; it is not dependent on the weather; and it has a consistent, if modestly lucrative, standing in the marketplace.

Watermelon in blue Russian dish
Deborah Deichler
Oil on canvas, 1993
13⅜ x 12 in. (34 x 30cm)

White peaches with plum wine
Deborah Deichler
Oil on panel, 1997
9⅜ x 10½ in. (24 x 27cm)

An insect resting, moist fruit, and rich textures are all aspects of still-life painting that are commonly associated with the lively Dutch Baroque tradition, but here the artist has chosen a higher viewpoint that offers a more immediate experience. Both of these pictures by Deborah Deichler employ underpainting, wet-into-wet, and glazing techniques in seamless combinations to achieve a naturalistic effect. The leaning cane and spilt sugar are examples of how small unexpected incidents within a painting can lift it out of the ordinary. In both pictures a knife handle is carefully placed to project toward the viewer.

Three bananas
Brian Gorst
Oil on canvas, 1995
10 x 8 in. (25 x 20cm)

Order and chaos are the underlying themes in this painting. The classically balanced, sweeping curves of the fruit contrast with the transience of its mottled and scratched surface. This also extends to the alla prima method of the picture's production, where a visual truth is gradually created through the random manipulation and combination of opaque oil colors stuck to a surface. Most of the painting contains at least some Flake White, as this gives luminosity to the body color of the bananas, and Raw Umber is the ideal basis for the dark colors.

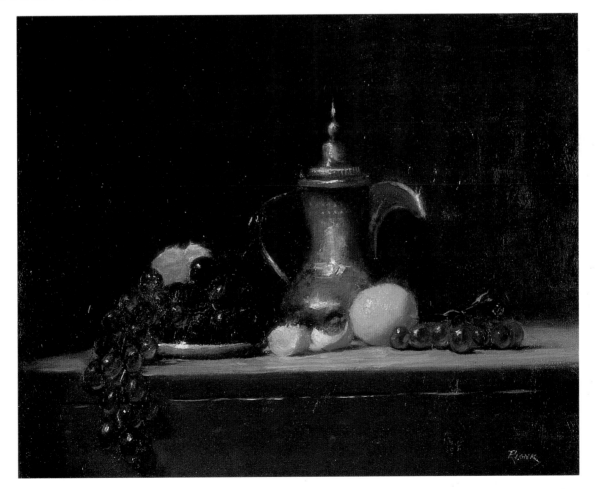

Turkish pot, **Richard Poink**
Oil on canvas, 1998
26 x 20 in. (66 x 51cm)

This picture is full of "air" (meaning a tangible sense of the space that surrounds an object), and is achieved through careful deployment of tones and by softening the outer edges of forms. The density of the oil medium gives us the depth of tone in the dark background and the rich color of the fruits. The larger orange mass is balanced by the smaller, less intense, orange area, and the upward curve of the orange segment is beautifully answered by the downward curve of the spout. To avoid an unwanted horizontal, the table edge is softened and placed at an almost imperceptible slope.

THEMES 2 # Flowers

The seductive charm of flowers, and their variety of color, form, and scale, have made them an irresistible subject for artists. The Dutch established a tradition of flower painting during the seventeenth century, emphasizing abundance and attention to detail. These lavish and highly finished pictures, often painted by dedicated specialists, required fine painting and design skills, combined with an extensive knowledge of the subject.

Other painters have used the subject of flowers as a challenge in economy and subtlety of handling. Fantin-Latour set the standard in the nineteenth century with his superb realist flower pictures, and Manet used an alla prima style to great effect to capture this most transient of subjects. Van Gogh took the sunflower and gave it a personality of sincerity and radiance, while Georgia O'Keeffe used enlarged flowers in isolation to evoke an enigmatic sensuality.

Flowers are highly perishable. To overcome this, either replenish the flowers periodically as you progress from bloom to bloom or work in a rapid and flexible manner from the start. The background behind flowers can often be difficult to achieve, as the silhouette of the subject is usually complex and irregular. Minimize the problem by using a uniform, neutral, and opaque background color, applied if possible in a different painting session to the flowers themselves.

White roses
Kim Williams
Oil on board, 1998
20½ x 19 in. (52 x 48cm)

As the experienced gardener knows, the charm of flowers lies not only in their color but also in the delicacy and lightness of their shape. Here the artist has painted the flowers with a limited palette of grays, browns, and earth greens. An underdrawing was sketched in charcoal on a light red-brown ground and the composition was gradually achieved over a couple of days. The shadows among the petals were painted, tonked, and left to dry overnight before the lighter areas of the petals were painted on top. Filberts and round brushes were useful in achieving the repeated crescent shapes of the petals.

Poppy, Oase
Joe Anna Arnet
Oil on canvas, 2001
16 x 20 in. (41 x 51cm)

Although this composition was painted in an alla prima manner, with loose brushwork and areas of impasto, care was taken to keep the red and white flowers separate from the green leaves and not to allow one to blend into the other. This has resulted in an intense color effect and is a genuine response to flowers that the artist grew in her own garden. The background is dark but not completely black, and it is lighter than the back of the tablecloth. This restraint is important, as the use of black would have stifled the color of the subject and flattened the feeling of depth behind the picture.

LEARN FROM THE MASTERS

Sunflowers
Vincent Van Gogh
Oil on canvas, 1889
29 x 39 in. (74 x 99cm)

Van Gogh painted many pictures of flowers and his depictions of sunflowers are perhaps his best loved. Rather than simply analyze and illustrate the colors and tones, Van Gogh has conveyed the expressive and emotive charge of the flowers using thick impasto and unrestrained color. There are no shadows and the background and table are flattened into decorative support for the sunflowers. The yellow background is unusually similar to the subject, but its coolness emphasizes the warmth of the flowerheads whilst giving the entire surface an almost symbolic sunlit radiance.

THEMES 3 # Landscape

There is huge variation in subject within the genre of landscape, from an edge-of-woodland pastoral idyll to a riotous stormy seascape. Oil paint has proved to be the medium most capable of capturing the high tonal contrast and textural variety found in the open landscape.

A landscape subject is usually far enough away from the eye of the painter to require some sort of abbreviated rendition upon the canvas and hence the manner of the painted landscape has recurrently been one of loose brushwork and generalized masses. Indeed, because a scene is often interpretive rather than strictly topographical, landscape paintings can become very abstract in form.

Seasonal changes in the landscape provide a perpetual range of challenges. Fall offers naturally harmonious color combinations that can be beautifully captured with earth pigments. Dramatic tonal and silhouetted features on stark backgrounds are often found in the winter landscape. Spring is a time to capture fleeting blossoms and yellow-green hues. Summer offers color intensity and tonal contrast, although the sun can be both a help and a hindrance.

Leckhampton Hill walk
Nigel Jensen
Oil on canvas panel, 1996
24 x 17 in. (61 x 43cm)

While landscape sketches and alla prima studies give the viewer an often fleeting impression of a landscape, Nigel Jensen strives for a richer and perhaps more complete account. This picture synthesizes information gained from a number of sittings and has been built up slowly from an underpainting through to a finish that uses subtle combinations of broken color and glazing applications. The picture displays many of the characteristics of "aerial" or "atmospheric" perspective, whereby the landscape in the farthest distance appears cooler (bluer), less contrasting in tone, and less defined than the foreground.

The wooded lake at Fontainbleau
Paul Kenny
Oil on canvas, 1993
60 x 42 in. (152 x 107cm)

This landscape study uses a few earth colors applied with economy onto a pale, warm ground. Differences in the texture of the sky, trees, and water are conveyed through subtle blending and a variety of brushmarks. (The shorter dashes at the top of the trees contrast with the horizontal strokes of the lake.) The strength of this picture lies in the complementary relationship between the area of subdued red-brown on one side and the area of muted green opposite. This, along with the yellowish hills and the blue sky, offers a full breadth to the color scheme.

A Suffolk farm
Alan Oliver
Oil on canvas, 2001
11 x 9 in. (28 x 23cm)

This lively work shows all the hallmarks of having been painted *en plein air:* brevity of marks, simplicity of palette, and spontaneity and freshness of execution. Across the surface can be seen the characteristic marks made by a bristle brush loaded with thinned oil color. This is interspersed with the sgraffito lines of the field and posts, made using a rag, which reveal the light-tinted ground. A painting of this size and finish would probably be amongst a number of studies completed during one day's outdoor painting and may stand alone or be used as reference for a studio-based work.

Red leaves, green trees
Brian Gorst
Oil on canvas, 2001
30 x 20 in. (76 x 51cm)

Painted out of doors in three hours, this small study is an attempt to capture the scene after a storm, when colors in the landscape can be at their most vibrant. The challenge was to employ broken color and pointillist effects without the paint strokes blending into each other and killing off the color. The fallen leaves in the foreground are larger and warmer than those farther away. The palette relies heavily on a Cadmium Green Light to achieve the moss-coated trunks.

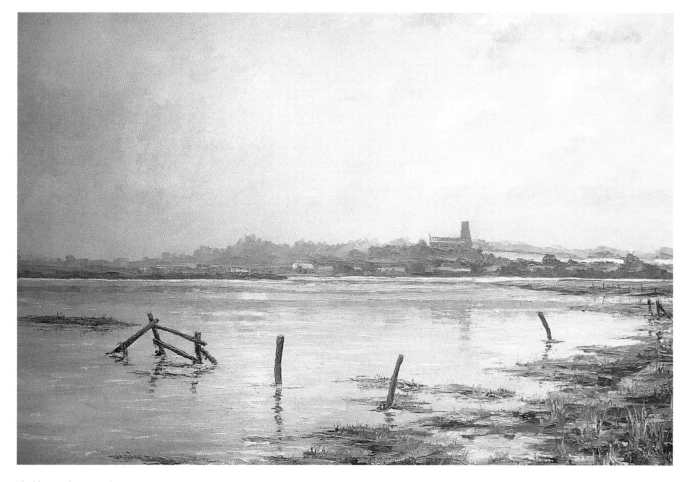

Blythborough across the estuary
Brian Bennett
Oil on canvas, 1996
30 x 20 in. (76 x 51cm)

Brian Bennett has managed to capture the sense of vacancy and melancholy that often accompanies the sight of still floodwaters. Although it was painted using a knife, the surface of the canvas does not attract undue attention to itself; there is real depth in the picture and the small town shimmers in the distance. A recurring device in landscape is to place the highest point on the horizon at around the two-thirds mark across the picture, as is the case with this church and its tower.

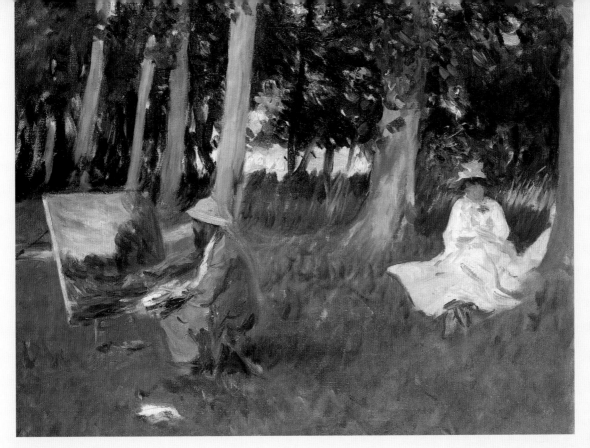

LEARN FROM THE MASTERS

Monet painting on the edge of a wood
John Singer Sargent
Oil on canvas, c. 1885
38 x 28¾ in. (97 x 73cm)

The vibrancy and exuberance of working *en plein air* can be observed in both the subject and style of this painting by Sargent. There is movement all over the canvas and Sargent has taken pleasure in making Monet's palette the most intense and animated area of the

picture—a comment, perhaps, on his reputation as one of the greatest colorists of all time. Note how few trappings the artist has around him—just a loaded palette and brushes, a canvas on a simple easel, and a sun hat to shield his eyes.

Tips for working outdoors

Some landscape artists paint entirely in the open air, while others merely make preparatory sketches on site and carry out more involved work in the studio. (Direct use of color can be replaced with words as in the annotated drawing below.) If you are working out of doors, it is useful to take more than one canvas or board and a sketchbook, especially in the summer when the light can change dramatically. A few salient horizontal and vertical measurements and the use of a rectangular viewer will help overcome the problem of

foreshortening that is common with distant views. Using a limited palette and working off a toned ground are ways of making effective use of your time in the landscape (reducing the number of decisions to be made and amount of paint that is needed) and are in keeping with alla prima, the method most often employed out of doors (see page 56). A peaked hat will help to shield your eyes from the sun and warm clothes are recommended at any time of year.

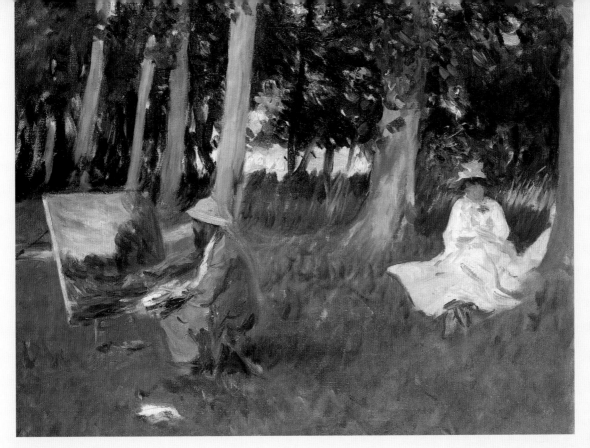

THEMES 4 # Townscapes

From the refined Venetian vistas of Canaletto to the evocative depictions of the American Edward Hopper, towns have given the painter a subject that is very different in nature to the rural landscape. For many, the town is their most familiar environment, full of repetition and regularity. However, by hunting out subjects, perhaps viewing scenes through a camera to better frame them, the artist can discover the townscape's potential for dynamism, unusual color schemes, and intriguing narratives.

The structural nature of buildings may result in frequent verticals that must be placed with care to avoid over-dominance. The presence of horizontals and diagonals is related to the painter's location. Dealing with perspective can be daunting at first; holding a brush in a horizontal position at arm's length is a simple way to observe the general inclination of diagonals and receding edges. An accurate underdrawing with fine lines will avoid errors later.

Color in a townscape ranges from the monochromatic to the fluorescent, and there is always a great variety of texture. Scumbled and scraped-back paint can produce realistic bricklike surfaces, whilst rain soaked streets and glass surfaces may invite a wet-into-wet approach. Painting on site can be very rewarding as one experiences the atmosphere of the location (including frequent enquiries from well-intentioned passers-by—this can be limited by wearing headphones!). Remember to set up your easel in a non-hazardous location, and be aware that changes in light throughout the day can change the appearance of buildings dramatically.

Council property
Patrick M. Smith
Oil on canvas, 1991
33 x 24 in. (84 x 61cm)

Here the artist has drawn on memories of a familiar environment to transform, through the process of painting, a perhaps mundane subject into an engaging and beautiful composition. The simplicity of the picture is countered by the subtly uneven nature of the horizontals and verticals, each window differing from the next. The overall blue-green color scheme contains a great variety of saturation and value. Brushstrokes used to depict the sky, buildings, and ground are varied in their application in order to emphasize differences in surface texture.

Noon
Bryn Craig
Oil on canvas, 2003
48 x 48 in. (122 x 122cm)

This painting is taken from a series of four pictures depicting different times of the day in a single community. Bryn Craig has used crisp shadows and strong colors to evoke a real sense of time and place. The subtle tapering of the leaning tree trunk and the canopy of leaves soften the repeated verticals of the buildings behind. The figures in the shade and the hanging flag glimpsed through the trees create secondary points of interest within the overall design. An underpainting was employed to help establish the complex perspective and then overpainted in blended opaque and semitransparent colors.

On the waterfront
Walter Garver
Oil on Masonite, 2003
24 x 34 in. (61 x 86cm)

Within the urban landscape, and particularly in industrialized locations, there is often great potential for dramatic use of scale. In this picture, the vessel is dwarfed by the sheer size of the building; the small tire on the wall of the waterway adding to this impression. The artist has used the extended portrait format and a low eye level to good effect in generating a sense of verticality. Although the picture surface appears uniform, it actually contains carefully combined wet-into-wet, scumbled, and layered applications.

THEMES 5 # Portraiture

Portraiture can appear to be the most restrictive theme for the oil painter because of its implicit single subject. For many centuries, however, it was central to the working practices of most masters, and its limitations in format only serve to make the differences between great and mediocre portraits all the more acute.

Multiple portraits offer an opportunity for compositional design, but the logistics of such an undertaking will probably involve the use of less spontaneous techniques. Double portraits are notoriously difficult because of issues of asymmetry and repetition. The self-portrait, from Albrecht Dürer to Frida Kahlo, has often been a place for intrigue, complexity, and idiosyncrasy, and is an ideal way to further one's portrait skills.

A conventionally painted oil portrait is usually completed in a number of sessions and frequently involves a measured underdrawing, a tonal or simplified underpainting, and a full-color final application. The face and hands are traditionally painted in isolation before the garments and background; and the eyes are often the first facial feature to be depicted.

The commissioned portrait requires a certain sense of professionalism combined with an inner confidence in one's own vision, and can be one of the most lucrative outlets for the painter.

Head study, **John Elliot**
Oil on canvas, 1998
20 x 24 in. (51 x 61cm)

Painted swiftly and with a confidence that suits the character of the subject, this painting is a prime example of an alla prima portrait study. This would have been executed in one session as a preparatory sketch for a more complex study, the first lay-in awaiting overpainting, or a spontaneous picture in its own right. Painted with a simple palette on a white ground, the artist has exploited his color range to achieve a sensitive warm/cool variety across the face.

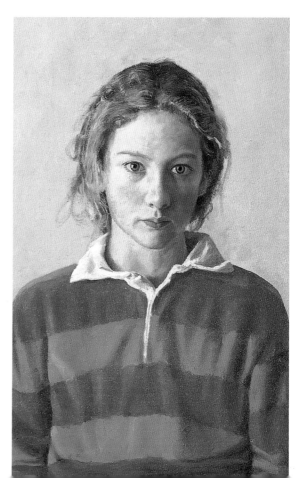

Agnes
Brian Gorst
Oil on canvas, 1995
12½ x 19 in. (32 x 48cm)

An engaging effect can be achieved when the subject of a portrait returns the gaze of the viewer, as in this portrait of a twelve-year-old girl. It was painted in a number of sessions on a pale green ground with an underpainting for the facial area. The fine delicacy of the eyes and lips becomes looser and broken in the hair and clothing, and the rugby shirt was chosen to juxtapose the innocence of the sitter's expression. The neutrality of the pale gray background is important to push the more chromatic sitter forward, especially as she is located so close to the picture edge.

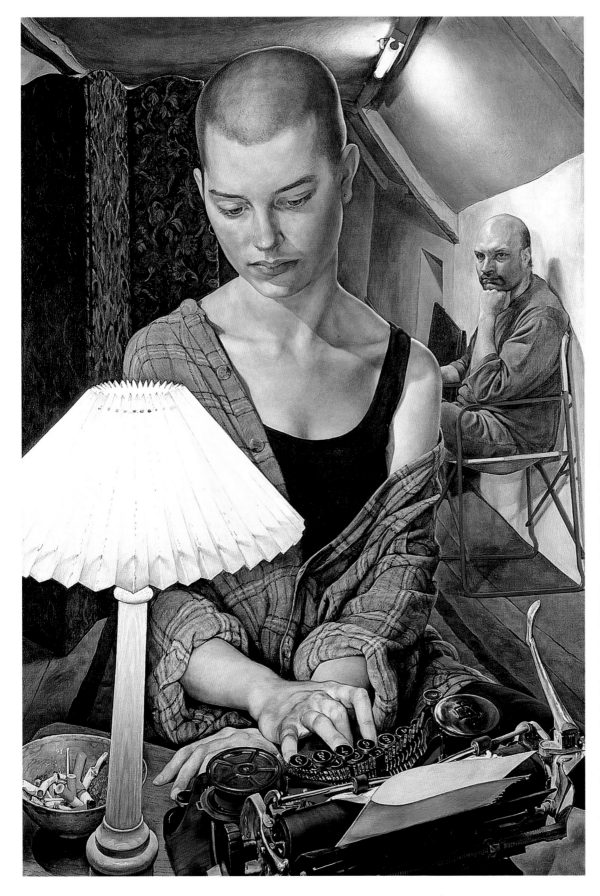

Alice and Clive
Michael Taylor
Oil on canvas
1999
38 x 42 in.
(97 x 107cm)

In this complex
double portrait,
the figures are far
enough apart to
denote a primary
and secondary
interest and yet the
painter, unlike a
photographer, is
able to keep both
figures in focus.
Painted on a warm-
colored ground, the
flesh tones are
surrounded by a
predominance of
subdued violet-
browns and creams,
while the intense
red of the typewriter
ribbon and the chair
are smaller notes
that help link
foreground and
background (see
Color echoes, page
45). There are
particularly subtle
modulations of
neutral color in the
flesh of the hands
and face.

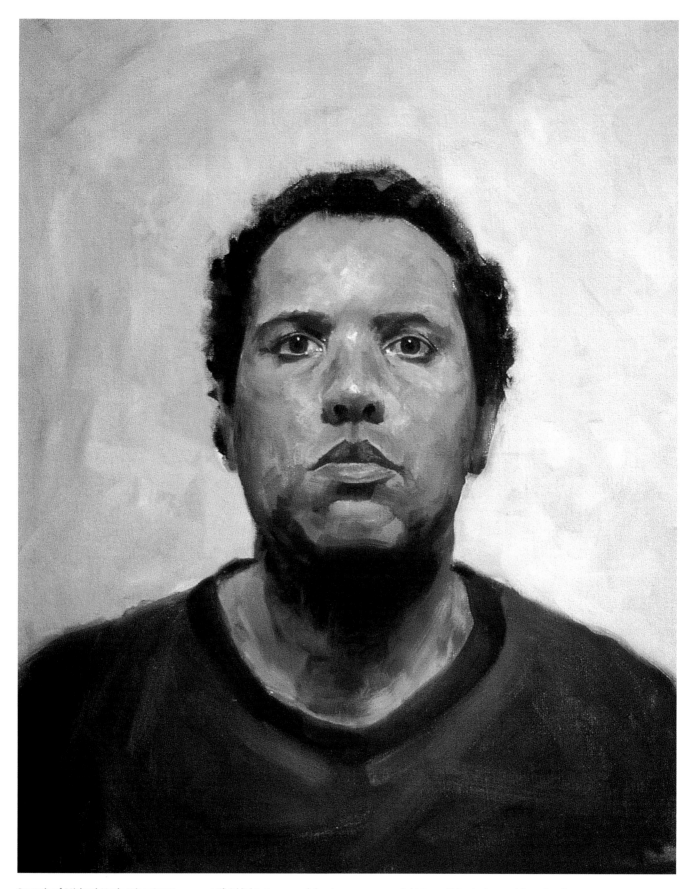

Portrait of Michael Mark, Brian Gorst
Oil on canvas board, 1997
16 x 20 in. (41 x 51cm)

An olive-green colored ground was employed in this portrait, completed in four hours in artificial light. A measured drawing was transferred onto the canvas panel and it was this accuracy in the underdrawing that allowed the alla prima paint handling to become free and loose. Neutral and complementary colors were observed as the light turned into shadow, and the color of the sweater was chosen to contrast gently with the flesh tints. Flat and bright brushes were used generally, with smaller brushes to capture the detail of the eyes and mouth.

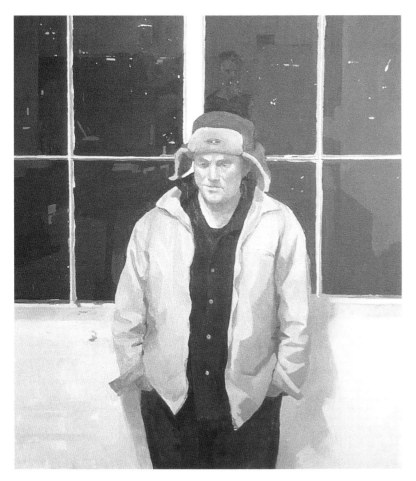

Adrian
Jason Line
Oil on canvas, 2001
34 x 38 in. (86 x 97cm)

What at first appears to be a fairly straightforward portrait of a young man in contemporary dress actually reveals itself to be a sophisticated example of the traditional "painting within a painting." The interior of the room is reflected behind the figure, with the artist himself in the act of painting, and beyond this scene is depicted the nocturnal skyline of a large city. It is the careful judgment of value ranges for the three depths of the picture that maintains order within what could be seen as a modern classicist composition.

LEARN FROM THE MASTERS

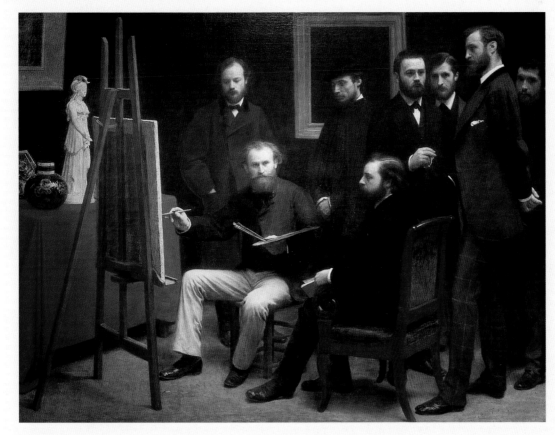

Studio at Batignolles
Henri Fantin-Latour
Oil on canvas, 1870
107 x 80 in.
(272 x 203cm)

The group portrait, often called a conversation piece, was particularly popular amongst French painters of the late nineteenth century who would use group portraits of themselves and other artists and writers as a way of promoting their collective ideals and solidarity. Fantin-Latour has carefully arranged the figures here to avoid a repetition of pose, varying the height and direction of the subjects. He has managed to achieve an overall consistency of paint handling even though each portrait will have been painted in separate sittings and, perhaps, different locations.

THEMES 6 # Figure painting

Arguably, the greatest achievements in painting have been in the form of figure compositions. The beauty and complexity of the human subject, and the many contexts in which it can be explored, have led to a vast range of religious, political, allegorical, and social narratives depicted in paint. The subject can encompass aspects of still life, portraiture, and landscape.

The figure is a primary and vital motif, as it can reflect the thoughts and emotions of an individual as well as the state of the human condition. The clothed figure is approachable and contemporaneous in a way that the nude need not be, and these two strands of the genre are often tackled in quite different ways. The nude has its own tradition, and its observed study is still valued as an aid to learning.

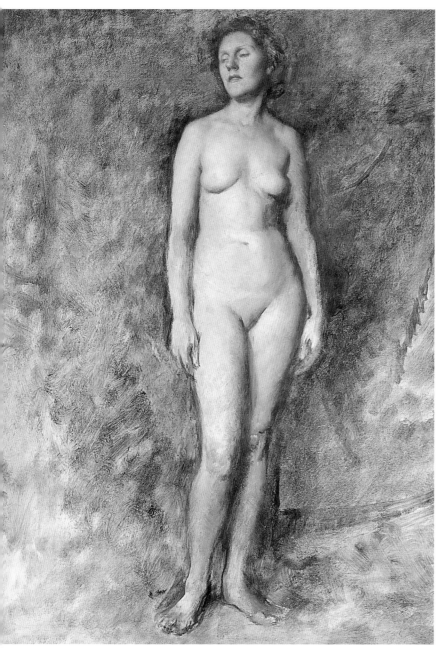

***The model, Mrs Stubbs, standing,* Victor Hume Moody**
Oil on canvas, 1948
14 x 18 in. (36 x 46cm)

The relative neutrality of the colors found on the human body makes it possible to paint the body with a limited palette. This is clearly demonstrated here in this study by the classical figure and portrait painter, Victor Hume Moody. The pose of the model was first drawn in Raw Umber oil color on a lightly tinted ground; then, in the same session, a white was introduced to produce the loose monochromatic underpainting that is visible on the body. During a second painting session the face was overpainted in greater detail using a more traditional flesh palette.

Seated male nude
Brian Gorst
Oil on canvas, 1998
18 x 18 in. (46 x 46cm)

Painted in a life class over four three-hour sessions, this is a good example of how a dark brown ground can be used in the shadow mass. The light masses were mapped out and the background tone applied in an initial thin coat on a bole ground. The shadow mass required only minor indications of deep shadow and ambient reflected light. It is important to note that over half of the picture is plain background and that the positioning of the figure within the square format was therefore chosen with care.

Resting model
Peter Kelly
Oil on canvas, 2001
15 x 10 in. (38 x 25cm)

In this calm and serene figure painting, the model is treated primarily as one element within the whole composition, and the paint is applied in an even-handed way across the surface. The bold sweep of the drapery moves the eye around the composition and the figure rests between the carefully judged dark and light contrast of the piano and sofa. The pots on top of the piano are the key to this picture, as they create both an earth-red echo of the model's flesh tones and a lyrical analogy to the female form.

Man and horse
Brian Gorst
Oil on canvas, 2000
14 x 11 in. (36 x 28cm)

Made as an oil sketch for a larger painting, this simple figure and horse arrangement was born out of a quick sketch. The male figure was assembled from a photographic reference and the outline of the horse was copied from a painting by Théodore Géricault. The figure and horse are the main subject of the picture; the background and trees are chosen and arranged with the sole purpose of enhancing their movement and adding to the dramatic mood.

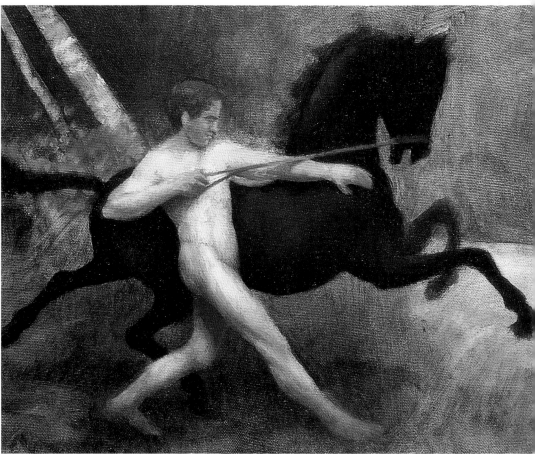

The princess and the frog
Deborah Deichler
Oil on linen on aluminum panel, 2000
35⅛ x 46⅛ in. (89 x 117cm)

The fairy-tale subject matter of princess and frog is tempered by the startling naturalism of the artist's approach. The painter has combined opaque and transparent applications across the surface and the red hanging cloth was repainted several times until the existing perfectly judged color was achieved. There are many artistic influences at work here—the hanging baskets are reminiscent of Dutch seventeenth-century genre painting and the figure has the delicate realism of the late-nineteenth-century academic painters—yet the picture has an overwhelming sense of originality and immediacy.

Delph brass banders
John McCombs
Oil on canvas, 1994
12¼ x 8⅞ in. (31 x 23cm)

The movement of these two band members playing is repeated in the swift movement of the artist's brushwork. Underlying areas of flat, broadly applied color combine with strongly linear directional strokes. A deep red ground can be glimpsed through the paint and this chimes with the warmth of the faces. The clothed figure is a recurring motif in McComb's work, often wearing brightly colored dress, which can add visual excitement to a figure composition.

Flesh palettes

Mixing an accurate flesh color is important if figures are to appear at all naturalistic. Generally, the color of flesh is a muted, pale orange; it can appear slightly redder, yellower, darker, or more neutral depending on such factors as age, ethnicity, the exact location on the body, and the obvious effects of form and light. The standard flesh tint is a mixture of red, yellow, and white, neutralized by using a touch of blue or black. Yellow Ocher, Earth Red, and Flake White are the kinds of pigments traditionally used along with the darker umbers in the shadows.

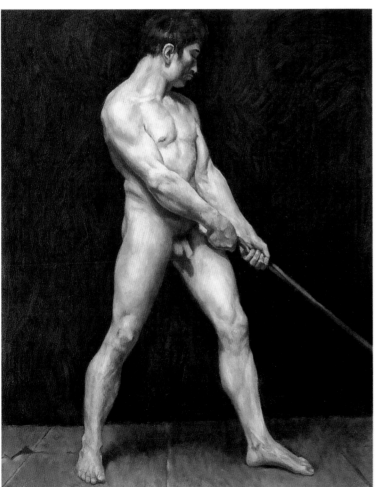

Standing nude (after nineteenth-century French School), Brian Gorst
Oil on canvas, 1998
24 x 30 in. (61 x 76cm)

The standing nude study has been central to academic training since the eighteenth century, and offers the painter one of the most rewarding subjects with which to exercise oil-painting skills. The strength of the male model is highlighted by the choice of pose, and the eye is taken along the muscle groupings and the flowing outline of the figure. Painted on a light olive-green color that remains visible in the half-shadows, and containing much color variation in the flesh, this painting was achieved with the three-string palette opposite.

THEMES 7 # Abstraction

Abstraction is the liberation of form from subject—one of the great achievements of twentieth-century art. Its development gave painters not only the freedom to express beyond the merely representational, but also a formalist language with which to evaluate all art.

Oil paint has been used to promote many of the strands of abstract painting, though in large-scale compositions or those in the "hard-edged," "op-art," or "color field" modes of abstraction, acrylic-based paints or mass-produced house paints have perhaps become a more economical and practical alternative.

Oil paints still have a broader color range than most mediums, with almost no color variation upon drying, and so are of use to the abstract painter pursuing exacting color relationships. The maneuverability of oils allows extreme gesture and expression to be captured on the canvas and to retain many years later the appearance of freshly applied paint.

Landscape: Bluebell Hill, Kent
Roy Sparkes
Oil on canvas, 1975
30 x 20 in. (76 x 51cm)

The line between what is representational and what is abstract can at times be very fine. This landscape by Roy Sparkes highlights the way in which forms can subtly discard their original subject. The parallel upward lines of the road have lost their perspective, the gray hill sits in the same space as the sky that surrounds it, and linear marks in the distance hover in front of flattened fields. A limited palette is deployed sparingly across the surface, and what the picture loses in realism it gains in panache and lyricism.

U-turn
Brian Gorst
Oil on canvas board, 2001
6 x 8 in. (15 x 20cm)

This simple abstract is one of a series of small studies designed to explore motifs and color relationships before commencing larger works. The full-strength blue and red are carefully mixed to the same value so that they resonate against one another. Abstract painters often actively pursue such optical effects to excite the eye of the viewer. The original U-shaped motif proved a little too obvious and so the cloudy rings were added later.

On Chesil Beach
Jeremy Duncan
Oil on canvas board, 2002
10 x 10 in. (25 x 25cm)

Although Jeremy Duncan paints primarily in the landscape and still-life tradition, some of his studies evolve further in the studio into abstract compositions, retaining certain colors and shapes but losing any sense of perspective and form. In this painting, sable brushes dragged paint in dynamic scumbles across a dark brown ground. There is an emphasis on the single concise gesture. The paint surface was worked upon flat, rather than at an easel, allowing greater freedom to place brushstrokes at unexpected angles.

Untitled
Matthew Leahy
Gloss paint on canvas, 1991
36 x 24 in. (91 x 61cm)

This painting was once three individual canvases with a quartered check pattern on each. The canvases were joined and paint was dripped onto the canvas, first from one side and then from the other, resulting in an enigmatic arrangement that displays elements of both order and chaos. Being essentially achromatic, the painting's strength relies on the dramatically rhythmic and subtly top-heavy distribution of its darks. It was painted using thinned household oil-based gloss paint, which dries considerably faster than tubed oil color but has neither its range of color nor its lightfastness.

North East
Lucy Voelcker
Mixed media on wood, 2001
50 x 39 in. (127 x 99cm)

Lucy Voelcker's work is often a response to the journeys she has made in unfamiliar locations such as the Sahara Desert. *North East* is a subjective and reflective abstract picture, exploring the inner landscape of the artist, as shaped by this experience. Mixed media, such as sand, paper, and chalk, are used to good effect and there is a rawness to the mark-making and composition that excites the eye. A number of marks and shapes in this picture are what can be referred to as "motifs," and these function, as in many abstract paintings, as subliminal signs, statements, or points of focus.

Untitled (and detail)
Michael Mark
Oil on canvas, 2000
72½ x 64 in. (184 x 163cm)

Many abstract painters avoid the use of gesture and brushstroke in favor of a pure display of color relationships and compositional design. To achieve this so-called "hard-edged" mode of picture making, the artist will often use masking tape to shield one area of paint application from another. Michael Mark has used this to good effect here: a number of layered passages intersect to create a highly active surface that contrasts well with the understated color scheme. In the detail photograph, the surface is revealed and a few traces of earlier diagonals can be picked out.

Untitled
Brian Gorst
Acrylic and oil on card
2001
8 x 6 in. (20 x 15cm)

When freed from the constraints of recognizable form, many painters find that making abstract pictures is simply a lot of fun. This painting was one of a series of studies exploring as many techniques as possible on a small scale. From approximately thirty abstract studies, only around one fifth were deemed successful enough to transfer to a larger scale. A series of translucent glazes were painted in acrylic over a white ground. Drips of oil paint were casually applied, followed by a thin veil of Zinc White in hazy strips.

THEMES 8

Working from the imagination

Although it is to be hoped that artists approach all themes imaginatively, there are those whose subject matter is more self-generated than observed. The sketchbooks of Leonardo da Vinci hint at a mind that not only analyzed the world around him, but wished to synthesize and transform it into paintings of idealism and originality. Correggio finessed his oil paintings into dreamlike allegories, while El Greco transformed standard religious subjects into ecstatically painted personal visions. Surrealists, such as Dali and Magritte, used oil paint in its most direct and pedestrian manner, in order to illustrate better the straight-faced nature of their ironic ideas.

A work from the imagination can often begin with a very small idea, scribbled down in a sketchbook or noted in words. By developing these ideas gradually, first through sketches and then in oil paint, one can quickly achieve a modest composition. What an invented subject may lack in accuracy of form and color, it often makes up in expression, mood, and originality.

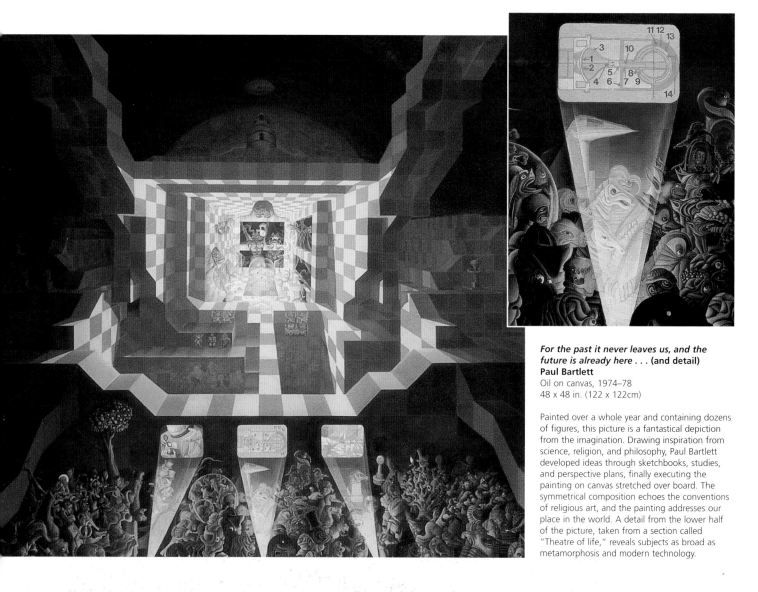

For the past it never leaves us, and the future is already here . . . **(and detail)**
Paul Bartlett
Oil on canvas, 1974–78
48 x 48 in. (122 x 122cm)

Painted over a whole year and containing dozens of figures, this picture is a fantastical depiction from the imagination. Drawing inspiration from science, religion, and philosophy, Paul Bartlett developed ideas through sketchbooks, studies, and perspective plans, finally executing the painting on canvas stretched over board. The symmetrical composition echoes the conventions of religious art, and the painting addresses our place in the world. A detail from the lower half of the picture, taken from a section called "Theatre of life," reveals subjects as broad as metamorphosis and modern technology.

Cendrillon
Deborah Deichler
Oil on canvas, 1999
54 x 62 in. (138 x 158cm)

An idea for a picture may be derived from the imagination and yet require observational painting within it, and this is the case with *Cendrillon*. The picture has intrigue and charm, with moments of surreal humor in the appearance of the cow at the window, but the scene is underpinned with accurate perspective and plausible lighting effects. The surface textures of the wall, cloth, and floorboards all keep the eye of the viewer moving gently around the interior and the deep blue of the night sky provides a welcome note of coolness to the warm hues of the candle and firelight.

New estate
Patrick Smith
Oil on canvas, 1991
37 x 29 in. (95 x 74cm)

The aggressive paint handling, discordant choice of colors, and ambiguity of finish of this picture give it an uneasy mood that was exactly what the artist intended. Painted from the imagination, it is a personal response to the building of new houses; the mock-Tudor buildings ironically overlaid in front of a green hill. Oil paint can be the best medium for such spontaneous outbursts as it maintains the freshness of a gestural response, and although *New estate* is a world away from the technique of the fifteenth-century pioneers, it is equal in its sincerity and pursuit of truth in painting.

My studio reflected in a circular
convex mirror placed on the floor
Paul T. Bartlett
Oil on canvas, 1974–75
15½ x 15½ in. (39 x 39cm)

Studio practice

All painting requires a certain amount of craftsmanship beyond the painting process itself and this is particularly the case when working in oils. This chapter tackles the preparation of painting surfaces and how to store and present finished works. It also suggests equipment and furniture that you may find useful and ways of organizing these into a creative, clean, and safe working environment.

The extent to which you involve yourself in the extraneous aspects of painting, such as making your own frames, depends on your own personal preference and skills. However, by explaining the principles of good, efficient studio practice, this chapter aims to give you the confidence to expand your oil painting from a hobby into a more serious activity, with greater output and professionalism.

STUDIO PRACTICE 1

Studio space

When it comes to setting up a studio space, every artist has different needs and resources. Here are some common requirements regarding space, lighting, and furniture, followed by suggestions for artists who specialize in specific areas.

If you're serious about your painting, you will want to be able to paint for long periods without being interrupted, and so a certain amount of privacy and control over noise and light will be vital. Remember, too, that you will probably also use your studio space for other tasks, such as preparing and finishing canvases, storing work, or as a temporary exhibition space. The size of your studio may be important if you want to work on a large scale, but you should also think about the cost of keeping such a studio warm.

Oil painters do not use large, heavy equipment or materials that require a solid floor surface. This makes it possible to use any floor of a house or building, and it is common to find a painting studio in an upstairs room of a house. Outbuildings, garages, and sheds are other feasible and economical possibilities, as are the many studio organizations or co-operatives found in most major cities. As with all other aspects of painting, time, cost, and your own preferences will be the deciding factors in your choice of space.

Lighting

An ideal light for a studio is even (providing general rather than intense illumination), neutral in color, and strong enough to light up the subject, the canvas, and the area in which you are working without becoming unmanageable or dazzling. It is difficult to paint in light that is either low level or intermittent and changeable. There is very little benefit in painting a picture in subdued light if previously unseen color imbalances or repainted passages are then highlighted in the blaze of a commercial gallery space. There is also nothing more frustrating

than the light fading away just as you enter a creatively exciting period.

Not all light is the same hue, and you should become sensitive to the variety in temperature and value of the light in your studio. Traditionally, artists have sought out northern daylight, which tends to give a consistent, cool-white light without direct sun entering the studio. Today the availability of artificial light sources has reduced the reliance on daylight, but although they allow you to work comfortably into the night, these lights have color limitations. Tungsten bulbs are

biased toward yellow or orange and are often dull; daylight-corrected tungsten bulbs can be a little too blue (sometimes violet-blue); and halogens tend to be a cool yellow, but quite bright. Perhaps the best option is daylight-approximated fluorescent strips, which give a more diffused source than bulbs and, if assembled into a series, can closest simulate the brightness and evenness of window light.

Studio contents

Unless you also use your studio as the setting for interiors, you should choose furniture that is functional and reliable, and can be wiped clean if it gets smudged with paint. The following suggestions are specific to oil painting; if you also work in other mediums, your requirements may be slightly different.

1 Preparation table You will need a general-purpose table, at an appropriate height, at which to prepare boards and canvases, varnish finished paintings, and, if it is strong enough, assemble stretchers and frames. The table must have a large, flat surface that can be wiped clean after use or covered with newspaper (formica, wood, or sheet metal would all be suitable surfaces). If space is at a premium, you could opt for a folding table, as a preparation table will not be in use all the time.

2 Painting trolley A movable storage and work surface allows you ready access to paints, mediums, brushes, and your palette. An old tea trolley with several shelves is ideal. Many painters of larger works (with palettes too large to carry) attach a sheet of plate glass permanently to the top of a trolley to support their palette. To keep the studio uncluttered, wheel the trolley under a desk or a table when not in use.

3 Storage racks Because they take such a long time to dry, oil paintings spend a long time in the studio. The most efficient way to house them is in a special storage rack. Whether you buy a ready-made rack or construct your own, it needs to have vertical openings of varying sizes, wide enough for your boards and stretchers and with enough space to allow air to circulate freely. You can adapt an existing shelf or storage unit by attaching parallel rows of wooden dowels to the inside. A few horizontal sections may be useful for works on paper or for paintings containing heavy impasto work, which may succumb to gravity if placed upright.

4 Shelving This allows you to keep objects such as containers, books, still-life props, and your radio away from the work surfaces and floor. Narrow shelving in a well-lit area is useful for propping up and assessing small studies on board or metal.

5 Desk Space permitting, a separate desk, at which you can work in sketchbooks or on paper in a clean, oil-free section of the studio, is a useful extra. It also gives you space to carry out administrative tasks such as cataloging transparencies of your work.

6 Seating When you are working on medium- or large-scale pictures, it is good practice to paint standing up whenever possible, as this allows you to stand back to gain an overview. However, you may find it easier to keep a steady hand while painting detailed or miniature work if you work sitting down. An easy chair can be a satisfying place from which to assess your work at the beginning and end of the painting day.

7 Storage cupboard Certain items that are not required all the time, such as tools, spare easels, stretcher bars, surplus paint, face masks, goggles, and so on, are best kept out of sight in a cupboard.

8 Wall space can be the most important commodity for the painter working on paper or on a large scale, as easels are often unable to support such works. It can sometimes be worth blocking off windows with large painted chipboard panels in order to achieve the required flat wall space.

9 Workstation For beginners or people who paint one or two days a week, a simple storage and preparation area within another room can be a first step toward setting up a studio. A foldaway table and a store cupboard/drying rack are all you need to prepare small boards or canvases and to mix mediums, decant thinners, clean palettes, and store paints and brushes.

Specialized studios

Different themes and genres lead to different requirements, and you should customize your studio space to suit
your subjects and the way you paint.

THE PLEIN-AIR PAINTER'S STUDIO

Many landscape painters paint exclusively outside, but
unless you are going to buy a boat to use as a studio,
as the pioneering nineteenth-century French landscape
painter Charles François Daubigny did, you will need a
place to prepare and store your canvases and panels.
A modest-sized studio, with plenty of work surfaces
and storage spaces and enough room for occasional
indoor painting and finishing, may be sufficient.

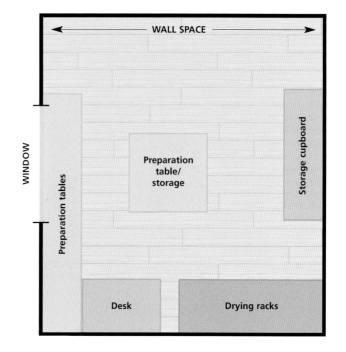

THE PORTRAITIST AND FIGURE PAINTER'S STUDIO

If you regularly paint portraits and figure studies, your studio
may need to be a little more like a domestic setting, as it
may feature in your compositions. It must also be warm—
particularly for life models. Some portrait sitters may not be
able to cope with harsh, artificial light. A dressing-screen,
sofa, or extra seating may be required. Positioning a seated
subject on a raised platform is also useful, as it allows you to
remain standing as you paint, maintaining the same eye
level as your subject.

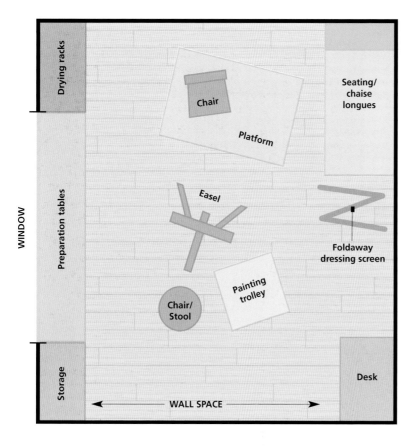

GROUP STUDIOS

Sometimes a private space is hard to find, and hiring a
studio as a member of a group can spread the rental
costs. Group studios of artists may be able to obtain raw
materials in bulk or afford larger workshop equipment
than would be possible alone. Such studios often
combine to curate a group show, spreading publicity
and production costs. Each member of a group studio
should be mindful of the needs of the others,
particularly different attitudes to noise and light; and
also be aware that the use of fixatives, spray varnishes,
and dry pigments, and the disposal of thinners, should
accord with health and safety guidelines (see page 123).

THE STILL-LIFE PAINTER'S STUDIO

Being able to control light is essential for still-life painting. Whether you are using daylight or a carefully diffused artificial source, the light must be of a consistent hue and value. Position the light on the side opposite your painting hand, to avoid casting an unwanted shadow on the area being painted. Arrange your subject on a surface against a studio wall adjacent to the light, making sure that it is at the correct height for you to paint comfortably. As a still-life painter, you will quickly amass a large collection of props, containers, cloths, and other items that need to be stored in readily accessible shelves or cupboards. You will probably need materials, card, and paper as backdrops for still lifes and these should be stored flat and cleanly. If you paint flowers and other perishable objects, it is best to keep the studio cool to prolong the life of the set-up.

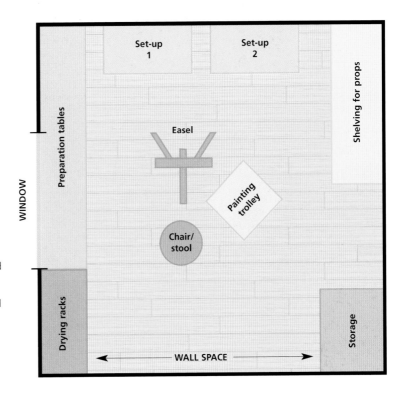

THE LARGE-SCALE PAINTER'S STUDIO

Painters who work on a large scale often sacrifice ambience and warmth in the pursuit of space and light. If one or two of an artist's pictures are enough to fill a wall, then they will need a large space with ample light, preferably from above, in order to free up valuable wall space. Large canvases will need to be stretched, prepared, and sometimes painted on the studio floor, so this must be spacious, level, and easy to clean. The studio door must be big enough to allow completed artwork through without being damaged.

Large preparation tables are invaluable, as are a mobile trolley and palette. Large-scale work is difficult to store and some pieces may have to be removed from stretchers or painted unstretched. A high roof and high walls can be utilized for added storage. When using large quantities of paint the presence of a sink in the studio, ideally with warm water, is a priority, as the need to clean hands is more acute (see Health and safety, page 123).

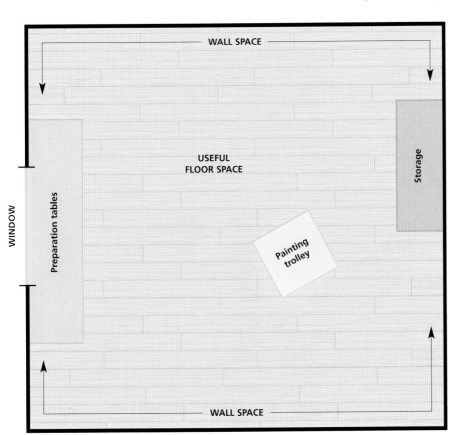

STUDIO PRACTICE 2 # Studio equipment

There are many tools and pieces of equipment in an artist's studio. You may not need everything that is shown here (framing and stretcher-making, for example, require expensive tools that are only cost effective if you use them regularly), but this section provides a helpful overview of what is useful.

1 For general use: masking tape, hammer, screwdrivers, pliers, craft knife, heavy-duty knife, scissors, and tape measure.

2 For economical use and preservation of paint: empty paint tubes and paint-tube squeezer.

3 For use stretching a canvas: large set square, tape measure, canvas pliers, and staple gun.

4 To smooth painting surfaces and frame moldings: glass paper, pumice stone, and sanding block.

5 To apply varnishes, grounds, and sizes: large brushes, large palette knife or spatula, spray gun, and spray diffuser.

6 To make rabbit-skin glue size: double boiler, hot plate, and measuring jug.

7 To produce stretcher bars, frames, and moldings: miter saw, miter block, saws, large set square, corner clamp, underpinner (not shown), and C-clamp.

8 To hang work for exhibition: spirit level, tape measure, mirror plates, fixtures, and picture wire.

Easels

If you've ever tried to paint a small- to moderate-sized painting without an easel, the benefits of using one will be clear. An easel can be moved to receive better light, can tilt the work forward to reduce glare, can allow you to work in your most comfortable position, and facilitates painting outdoors or in places without any other furniture. There are different kinds of easels and you may use more than one. A good-quality easel is one of the most expensive initial outlays an artist will make, but is a necessary and worthwhile purchase.

1 **Table easels** are, as the name suggests, small easels that are placed on a table or other suitable surface. Often used for displaying work in shop windows and galleries, a table easel can be convenient when you are attending painting classes. Wheelchair users may also find them less obstructing than larger studio easels.

2 **Sketching easels** are tripod-type supports that are made of hardwood, steel tubing, or aluminum. (Wooden sketching easels need to be varnished or oiled before they can be used outdoors.) Sketching easels are designed to be portable and to hold canvases or rigid supports up to a maximum height of around 30 in. (75cm). Some sketching easels allow work to be held at different angles and can also be used for watercolors or drawings. A good-quality easel of this type may be all you need if you are working on a small scale or in a small studio.

3 **Radial easels** are commonly used in schools and colleges. Composed of a single adjustable picture support with a solid tripod at its base, a radial easel is sturdy and suitable for most sizes of work. It can be heavy and awkward to adjust, but will take the weight of large paintings while still being convenient for very small work. A more complex version, with an angled joint halfway up to allow its use as a drawing or watercolor easel, is also available.

4 **Studio easels** are designed to hold heavy or large canvases on a support that is raised or lowered using a ratchet or winch mechanism. (Professional artists sometimes use a wall-mounted support with similar mechanisms for raising and lowering large paintings.) Castors are usually fitted to aid movement around the studio and many studio easels contain paint trays or storage compartments. Studio easels are quite tall when extended to their full height, and so may not be appropriate for small rooms.

5 **Box easels** are simply a combination of a painting box and a sketching easel. They are used by landscape painters on location and by portrait painters working in the home of their sitter. Available in two sizes, often with backstraps, fitted palettes, and a sliding drawer, a box easel functions as a portable studio and its usefulness is reflected in its high cost. A box easel occupies more floor space than any other type of easel and so can be impractical for serious studio painting.

Stretcher bars

Stretcher bars act as a frame to support a stretched canvas, providing a painting support that is light, reusable, and inexpensive. Manufactured stretcher bars are usually made of pine and are sold in pairs at various standard lengths. For stretchers larger than approximately 24 x 30 in. (60 x 75cm), crossbars may be needed to provide support against the tension of the stretched canvas.

Stretcher bars tend to be wider than they are deep and get progressively wider and deeper for longer lengths of stretcher bar. Unframed abstract works are usually painted on stretchers between 1 and 3 in. (2.5 and 7.5cm) deep, and the canvas is stapled on the reverse. Small- and medium-sized framed paintings tend not to exceed 1 in. (2.5cm) in depth, as the combined hanging weight would be too heavy and the depth too great.

The canvas must be wrapped around the side of the stretcher bar but must not touch it on the front side. If the inner edge of the stretcher touches the canvas during painting, an undesirable mark will occur on the painted surface. For this reason, stretcher bars are beveled or angled toward the inside, or more commonly have a raised lip on the outer edge. For unframed paintings this outer edge often forms a sharp, clean edge, but for framed pictures a rounded lip that places less wear on the canvas edge is preferable.

Slotted expandable lap joint with wedges

Fixed lap joint (without beading)

STRETCHER-BAR JOINTS

The slotted, unfixed joint, for framed or smaller canvases, can be expanded slightly once stretched by tapping the small wooden wedges inserted into the joint. The fixed lap joint is used in heavier stretcher bars for larger, unframed works and requires the addition of beading to lift the canvas off the stretcher.

PROFILES OF VARIOUS STRETCHER BARS

Standard stretcher for framed pictures

Simple tapered profile of stretcher

Quality stretcher for abstract paintings

Large-scale stretcher with attached beading

PROFILE OF STRETCHED CANVAS

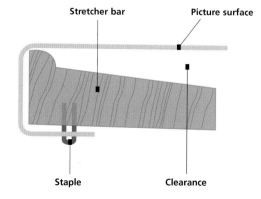

Stretcher bar
Picture surface
Staple
Clearance

STUDIO PRACTICE 4 Stretching a canvas

This is a method for stretching linen and cotton canvas over stretcher bars. Larger canvases are best stretched on a clean floor by two or four people. New canvas can be soaked for half an hour and dried before stretching to reduce the likelihood of future sagging.

1 Tap the stretcher bars together to make a frame and check its squareness with a large set square or by measuring from corner to corner with a tape measure. (Wedges are only used if stretcher expansion is required.)

2 Lay the stretcher frame beveled side down on the canvas and cut out the canvas, allowing an overlap of about 3 in. (7.5cm) all around.

3 Make sure that the warp and weft threads of the canvas are parallel with the edge of the frame. Pulling the canvas taut with canvas pliers, staple the canvas to the center of one of the longest stretcher bars and then repeat the process on the opposite side.

4 Do the same with the shorter sides, taking care to pull the canvas more taut with the second of each opposing pair of staples. (This prevents the canvas from being stretched unevenly.)

5 Return to the first long side and place a staple to the right and left of the first staple, 1½–2 in. (4–5cm) apart. Do the same on the opposite side, and then in turn to the remaining two sides. Continue working outward from the center toward the corners. (The longer sides will need more staples, so remember to miss out the shorter sides from the sequence on a few occasions.)

6 Gather and fold the corners around one or two sides and staple onto the back.

STUDIO PRACTICE 5 # Sizing a canvas

Size acts as a seal between the oil in the paint or ground and the fibers of canvas, board, or paper. The size does not need to be applied in a thick layer, but it should be flexible and long-lasting. Rabbit-skin glue is the traditional size and comes in pellets, sheets, flakes, and coarse granules. Acrylic size can also be used for oil painting and should be applied according to the manufacturer's instructions. Decorator's size and thinned white glue are not recommended, as they can become brittle in time.

To make rabbit-skin glue size

Two pints (1 liter) of size will cover approximately four 24 x 30 in. (60 x 75cm) canvases. The exact ratio of size to water will vary with each batch, and the quantities given here should be used as a guide only.

1 Mix 2 oz (50g) granulated size into 2 pints (1 liter) of cold water and leave to soak for over two hours in a heatproof container or the top half of a double boiler.

2 When the granules have swollen, place the container in hot or boiling water and stir to dissolve the granules into a uniform, semitransparent light brown color.

3 Leave covered in a cool place for over two hours to test the consistency: it should be gel-like but easily broken down. (If you are confident about the ratio of water to size in a particular batch, you can omit this step.) If the consistency of the gel is incorrect, repeat steps 1 and 2 to add more water or granules to the mixture.

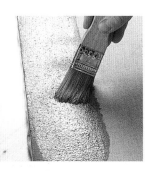

4 Reheat in boiling water to dissolve the size once more. Apply warm size in even strokes across the surface of the canvas and on to the sides. Once dry, smooth any irregularities lightly with a pumice stone.

TIPS FOR USING SIZE

• If the canvas needs two coats of size, the mixture may be too thin. One coat is recommended.

• For larger canvases the water in the double boiler may need to be heated repeatedly throughout the process so that the size remains fully dissolved.

• Cotton does not absorb size as well as linen and may need a more loaded or stiffer brush.

STUDIO
PRACTICE 6
Preparing boards and panels

Manufactured boards and wooden panels are used and prepared in similar ways. The factors you have to consider when choosing boards are their cost, weight, absorbency, and resistance to warping (see Supports, page 19).

Supports and preparation

All sizes of wooden panel, and thin boards over approximately 18 x 24 in. (45 x 60cm), should be attached to a cradle or "chassis." This is a support with crossbars, similar to a stretcher but with a flat profile, that increases the rigidity of the board. The chassis can have simple butted joints held with nails or screws and should be glued with extra-strong wood glue to a board or panel of the same dimensions.

With thick boards, secure the board to the chassis by driving screws through the chassis from the back. For thinner boards, wood glue will suffice.

Smooth boards, such as hardboard, should be wiped over with methylated spirits to remove all traces of grease. Surfaces can be lightly sanded if desired and size is recommended for use under oil primer. Acrylic primer can be applied without size onto boards in a number of coats, lightly sanding between applications. Earlier coats may be applied diluted with a little water (although some manufacturers do not recommend this). A large painted cross on the rear of a board will help prevent warping by making the board bend in two opposing directions.

Paper and card need to be sized with thin size or acrylic primer to prevent them from absorbing oil from the paint. Metal surfaces need only to be degreased using methylated spirits, but reflectance can be reduced by applying a thin and even coating of Flake White, diluted with mineral (white) spirit.

Making a canvas-covered board

Canvas-covered board combines the strength and low cost of rigid supports with the texture of canvas. Thin linen or cotton can be used, and calico is also ideal. It is easier to cover boards in batches of at least five. A sized canvas-covered board can be painted onto directly with or without a ground.

1 Cut the canvas to at least 1 in. (2.5cm) larger than the board all around.

2 Cover the board with hot rabbit-skin glue size or cold acrylic size.

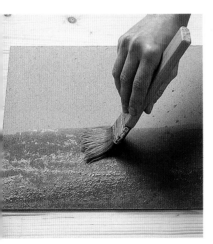

3 Place the canvas on the wet board, move it into the correct position, and smooth out any lumps or air bubbles.

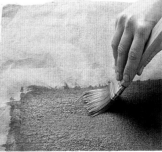

4 Coat the canvas sparingly with size to just beyond the edge.

5 Apply size to the back of any surplus canvas and board. Stick flaps down firmly and tightly around the edge.

STUDIO PRACTICE 7 # Priming

Priming is the application of a ground layer that gives the surface a uniformity, luminosity, and strength that size alone cannot offer. An oil-primed ground is generally considered the ideal surface to paint onto with oils. A primed surface can be painted after a month of drying, but for best results it should be stored for around six months. Alkyd primer should be treated as a quick-drying oil primer.

Acrylic primer and gesso can be conveniently applied to cotton duck, in a number of coats, without a size layer (an acrylic size is recommended for use on linen). Acrylic primers can be very absorbent and may draw oil out of the paint layers. This can be lessened by applying oil to the primed surface, wiping away the excess, and leaving to dry before painting.

Oil primer should be the consistency of pouring cream in order to penetrate the canvas fibers; you can dilute it with a little mineral (white) spirit if it is too thick. One coat provides the most flexible film, but if a second coat is preferred then this should be applied after a few days. Tubed oil color can be added in small quantities to tint the primer (see Applying a colored ground, opposite).

2 The oil primer should be smooth and flowing in consistency, like pouring cream.

1 The oil primer may need to be diluted with a little mineral spirit.

3 Applying the primer with a large palette knife (above) drives it into the surface and produces a smooth painting surface. Ensure an even covering before setting aside to dry. Using a brush (left) is an alternative method that provides a more even distribution of primer but leaves the canvas weave more prominent.

Applying a colored ground

Colored grounds are used for aesthetic reasons only and should therefore be thin and integrated fully with the white ground layer. Colored grounds can be applied opaquely or transparently.

Opaque grounds are applied sparingly with a brush over the front of a primed canvas. Alkyd white combined with oil paint and mineral (white) spirit creates an adequate quick-drying colored ground. For acrylic grounds, acrylic paint can be combined with acrylic primer and a little water. Opaque ground color can be made in large quantities to give a consistent color to all canvases and boards.

A transparent ground (sometimes called an imprimatura) covers the white ground but lets it show through, producing a richer color. Transparent grounds are effectively produced using oil colors, linseed oil, and mineral spirit and can be painted on after a week if quicker-drying pigments are used.

Applying a transparent ground

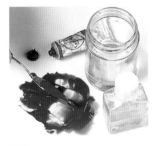

1 Mix a small amount of tube color with equal amounts of linseed oil and mineral spirit to a thick liquid consistency.

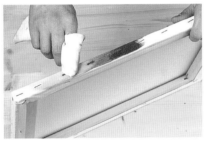

2 Test the color on the side of the canvas in varying degrees of density.

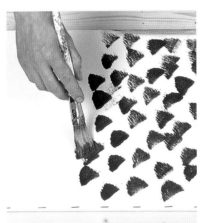

3 Mix enough to cover the canvas and apply the ground with a large brush in evenly distributed thick marks across the entire surface.

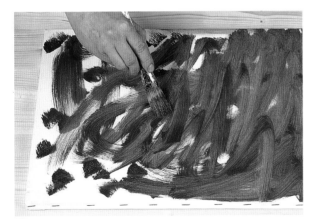

4 Even out the color with repeated long, firm strokes that pass across and beyond the canvas. Squeeze out excess paint from the brush onto paper and wipe around the edge of the canvas.

5 Using a soft, lint-free rag, gently remove some of the paint until you obtain a thin, smooth layer of the right value.

STUDIO PRACTICE 9 # Varnishing

Think of a varnish as a removable protective covering for the painting. After many years of exposure to the atmosphere, the varnish may have absorbed substances that darken or discolor the appearance of the picture: in this case it can be removed and replaced. The varnish should be made of a substance not used during painting in order to avoid the accidental removal of the upper paint layers.

Traditional picture varnish is made of damar or mastic resin, but many professionals prefer Ketone N resin because it does not yellow. Acrylic varnishes are also available for use on oil paints. (Check the manufacturer's instructions for any special procedures required when using varnishes.)

A varnish can be matte, gloss, or something in-between. Ketone and acrylic matte and gloss varnishes can be mixed to achieve the right finish. A high-gloss finish is more important on a picture that has dark values or rich glazes, or on a paint surface that is smooth and even, such as board or metal. A matte effect is appropriate for high-value, opaquely painted pictures with an impasto or a scumbled surface.

1 Clear picture varnish
2 Matte picture varnish
3 Gloss picture varnish
4 Extra-thin mastic varnish
5 Retouching varnish
6 Final varnish aerosol
7 Matte varnish aerosol

TIPS FOR APPLYING VARNISHES

- Varnish paintings around six months to a year after completion, depending on the thickness of the layers and the types of pigments and mediums used.

- Always varnish in a warm, dry, dust-free environment.

- Make sure that the painting and the varnish are at the same temperature.

- Apply the varnish with a spray gun to give an even finish. Thicker varnishes may need to be thinned with mineral (white) spirit for this purpose. (Mouth atomizers are not recommended for use, as they can introduce moisture into the varnish layer.)

- Aerosol spray varnishes are available in gloss, matte, or retouch varieties, but they can be prohibitively expensive as so much varnish misses the actual painting.

- Lay small works flat inside a sealed plastic bag or box with enough room for the spray gun or canister to enter, as this will conserve varnish. It is also a useful way of containing potentially harmful fumes if you have to varnish in a living area.

- Write the brand name and type of varnish on the reverse of the painting for ease of future removal.

Applying a varnish with a brush

When applying a varnish with a brush, remember to ensure that you have a good light, so that you are able to check the evenness of the applications.

1 Test the varnish on a small part of the painting using a white cloth. No discoloration of the cloth should occur.

2 With the painting lying flat, apply the varnish in long continuous strokes using a 2–3-in. (5–7.5cm) fine-haired brush. Each passage should overlap the previous one once only. Avoid overloading the varnishing brush.

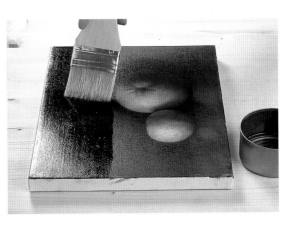

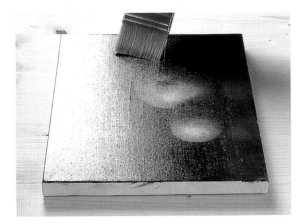

4 Wipe the edges of the stretcher. Once the varnish is touch dry, prop the painting against a wall, facing inward, or place it upright in a sealed cupboard or plan chest, and leave to dry. Most varnishes dry overnight.

3 After a few minutes, the varnish will start to set. To create a more matte effect, continue lightly brushing over the wet surface. (This is only necessary when using damar or mastic varnishes.)

Framing and presentation

A frame can protect an oil painting from damage to the front and sides and, by bracing the stretcher or solid support, can help prevent warping. Visually, the frame acts as an interval between the picture and wall and should highlight the painting.

Traditionally, oil paintings are framed in wooden frames that are gilded, painted, or polished. Due to its reflective nature, glass is usually reserved for works on card or paper, or to protect the surface of highly valuable pictures.

Larger canvases and many abstract works are often left unframed for sound aesthetic reasons, but remember that this practice works only if the wall on which they are hung is plain and neutral in color. Unframed works that look strong in a gallery space may appear less so in a cluttered and decorated domestic setting.

Frames should be sympathetic to the painting; a painting of limited value range should not have a very dark or a very light frame; bright colors should be avoided; and the frame should not be shinier than the picture surface. Moldings that are less than 2 in. (5cm) wide tend to look ungenerous and cheap, and smaller paintings often require a relatively large width of molding.

The surface decoration of frames ranges from plain to ornate, and should echo the nature and language of the painting itself. Gold has a long tradition as a finish suited to oil paintings and, with the addition of various patinas or surface treatments, this color can indeed serve as a surprisingly understated and sympathetic surround.

1 Gilded frame
2 Painted frame
3 Color-stained frame
4 Bare-wood frame

Making frames for oil paintings

Picture moldings of all kinds can be purchased in bulk, and frames can be made with a miter block, saw, and cord or corner clamp. It is sensible to upgrade gradually toward more professional and efficient framing equipment as your confidence and productivity increase, and to frame as many paintings as possible at one time to maximize your time and resources.

By using cheaper unfinished (bare-wood) moldings, you can apply stain or paint and specifically tailor the finish to each picture. Architrave and other moldings used for interior decoration can be modified for simple budget framing. (These tend to be flat-backed and shallow, requiring the attachment of a strip of wood to form the rebate that houses the canvas.)

The primary strength of a picture-frame joint is achieved through the combination of an accurately cut miter and strong wood glue. Nails and other fixings provide support, but are not strong enough to hold a joint on their own.

When working out how much molding you need for each picture, the standard formula is 2 x longest side + 2 x shortest side + 8 x molding width + 4 x molding width for wastage.

The painting should be held in the frame securely behind the front rebate of the molding, but with enough room to allow for any small expansion that may occur in the panel or stretcher bar.

CORNER CLAMPS

Once a miter is cut there are various ways of clamping a corner until the glue dries.

Strap clamp

Corner clamp

Sprung corner clamp

1 Large ring and chain
2 Plate ring and cord
3 Screw ring and picture wire
4 Sprung clip
5 Bracket
6 Turnbutton
7 Clip
8 Mirror plate
9 Z-clips (one fitted)

HANGERS AND BRACKETS

Hanging fittings are available in different sizes for lighter and heavier paintings. Various brackets are used to attach canvases to frames including bendable plates, turnbuttons, kidney plates, sprung clips, and Z-clips. (Take especial care when using tools around an upturned picture to avoid piercing the back of the canvas.)

Hanging and lighting oil paintings

Always hang a framed picture by its frame rather than by the stretcher bars, which are not designed to take any extra weight. Attach low-stretch nylon or picture wire to the frame, using D-rings inserted just above halfway on each side of the frame; this provides sufficient tilt to reduce glare, allows a constant passage of air to circulate behind the picture, and reduces the gathering of dust on the picture surface. Mirror plates are commonly used, particularly for exhibition purposes.

As with other works of art, oil paintings will suffer if they are hung in smoky or steamy environments, such as kitchens or bathrooms, or above radiators. Unwanted glare is best avoided by placing work next to windows rather than opposite them; and it is best to light a painting with one light on either side, rather than with one immediately above it.

Paintings should be hung at a slight tilt to reduce glare, allow the circulation of air behind the picture, and prevent dust from collecting on the surface.

STUDIO PRACTICE 11 # Suggested daily checklist

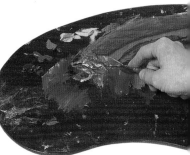

- Before you begin painting, assess any work in progress with fresh eyes, and plan what you are going to do during that session.

- Apply barrier cream to your hands and fingertips.

- Prepare medium in dipper 1 and use it to oil out any sunken areas of the picture. Place thinners in dipper 2.

- Squeeze out the amount of paint you think you will need to use during that painting session. Prepare tints and mixtures on glass with a palette knife.

- Select the appropriate brushes and rag, then commence painting.

- After painting, secure the tops of all tubes so that the paint does not dry out.

- Scrape excess paint from your palette and glass on to newspaper, and clean, using any remaining thinner and medium in the dippers.

- Wipe excess paint from the brushes on to newspaper. Working from the smallest brush to the largest, use recycled thinners to loosen paint from the brushes. Dry them on the rag. Wipe the brush handles.

- Clean brushes with soap in warm water, then rinse, squeeze dry, and lay them flat. (Water may run back into the ferrule and loosen the hairs if brushes are placed upright.) Work from the smallest brushes to the largest to avoid polluting the water all at once.

- Tidy the work area, and clean your hands and fingernails with hot water and soap.

- Assess the work in progress.

Cleaning brushes

1 Remove excess paint on a piece of newspaper and then loosen paint stuck to the brush fibers in mineral (white) spirit.

2 Clean the brush in warm water using soap until no more color flows from the fibers.

3 Rinse the brush in cold water thoroughly to remove the soap.

Health and safety

Oil painting involves the use of pigments and solvents that may be harmful. Handled sensibly and in limited quantities, however, the use of these substances should not pose any threat. The following guidelines are suggested as ways of maintaining safety and good health in the painting studio.

- A painting studio can contain toxic and flammable substances and so is not the ideal environment for young children or pets. Smoking, eating, and drinking in a studio should also be avoided.

- Clean hands and under fingernails whenever appropriate with a hand cleanser and hot water. Use petroleum jelly or mineral oil, rather than thinners (which can be absorbed into the bloodstream), to loosen paint from hands. Wear a protective apron or change of clothing for painting and leave these in the studio.

- Sustained inhalation of fumes from all solvents (including odorless varieties) can cause faintness and nausea. This is more likely in small, poorly ventilated areas or in group studios and classrooms. Solvents should be stored in sealed containers and used in dippers or jars with narrow openings; studios should have adequate ventilation.

- Solvents (particularly turpentine and methylated spirits) and thinned pigments can be absorbed through the skin and their continued use in large quantities without appropriate protection can be harmful. Use a water-based barrier cream when painting and wear protective gloves for any procedures involving continuous contact with large quantities of solvents. Always follow the manufacturer's guidelines on the suitability of creams and gloves for each task, as no one glove will protect against all solvents.

- Airborne pigment particles (caused by sanding dry paint, handling raw pigment, or spraying thinned paint) may be harmful if inhaled. Use an appropriate respirator when using raw pigments (check the manufacturer's guidelines) and clean relevant areas with wet cloths rather than by sweeping or brushing.

- Manufactured boards and panels (particularly MDF) often contain or are coated with harmful substances that can be inhaled along with the fine sawdust produced when these boards are sawed. Wear an appropriate respirator when sawing and use craft knives wherever possible to cut board.

- Varnishes and fixatives used in spray guns, aerosols, or atomizers can be easily inhaled when airborne, causing respiratory difficulties. Spray varnishing should be carried out in ventilated and open areas, and appropriate respirators and eye protection should be used.

- Solvents, paint rags, and used newspaper can pose a fire risk. Keep flammable substances away from naked flames. Empty trash cans frequently and clean up any spillages of oils and varnishes immediately. Store flammable solvents in a secure, cool place, such as a lockable metal cupboard.

- If you are concerned or in any doubt about your health, have a health check that includes a blood test. Pregnant women may wish to avoid the use of Lead White, cadmium colors, and genuine turpentine, as a precaution.

TIP FOR DECANTING SOLVENTS

All thinners used in the studio can be reclaimed to avoid harmful disposal. Pour used solvents or thinners into a settling container, seal, and leave for at least a week. After the pigment has sunk to the bottom and the thinner is no longer cloudy, carefully decant it into a sealable storage container for reuse.

Glossary

acrylic An alternative to oil as a binder of pigments, producing paints and grounds that are of selective use to the oil painter but which must never be painted on top of oils.

alla prima This term refers specifically to a painting finished in one session and also describes generally an attempt to capture the appearance of an object in one, unglazed, painted layer.

Baroque Loosely describing the prevailing European artistic movements of the seventeenth century and characterized by dramatic use of movement and light.

binder A constituent of the painting medium that creates a workable paint mixture from solid pigment particles and adheres the particles to a surface.

bole ground The name for a dark red-brown clay used as a ground color, or a colored ground of similar appearance.

bright A shorter-haired version of a flat paint brush that is useful in broken-color techniques.

brightness When used in the context of a painting, this term usually relates to the intensity of a color, rather than its value.

broken color The effect produced when a ground color or underpainting remains visible through a paint application due to scumbles, dots, or scraping-back.

canvas The linen or cotton material used to paint upon. Also the name given to a canvas on a stretcher ready for painting, or the finished picture itself.

cartoon A preparative drawing executed in the same size as the intended painting, and used as a direct means of transferring a drawing onto a support.

charcoal The charred twigs of willow or vine wood. The most suitable drawing material for use with oil paint.

chassis A simple framework attached to the rear of larger sized boards or panels in order to prevent warping.

chiaroscuro Literally meaning "light dark," this term has come to describe a strong tonality within a painting, particularly as an effect of a single light source within a dark environment.

cradle A complex and traditional form of chassis used to support wooden panels, which prevents warping while also often offering a certain amount of lateral expansion to the wood.

Cubism An art movement of the early twentieth century, developed by Picasso and others, which moved away from traditional illusionism toward a more interpretive, deconstructed, and abstracted approach to form.

dead coloring This term is sometimes used to refer to the initial laying-in of general color masses during a layered painting procedure.

dryer A substance added to the paint (usually at the manufacturing stage) to shorten its drying rate.

drying oil The generic name for all the substances used as binders in the medium.

extender An inexpensive and inert substance used to increase the bulk of many cheap paints, often at the expense of tinting strength and mixability.

fat over lean The practice of painting thicker and more oil-rich layers over the top of previously painted thinner layers with less or no oil in the medium, in order to prevent cracking.

Fauvism An early-twentieth-century art movement that exemplified free and expressive use of bright colors and flattened picture depth, and was pioneered by Matisse.

figurative Type of art that depicts recognizable subjects, such as still life, landscape, and the human form, as opposed to work that is purely abstract.

filbert A flattened brush shape that retains the curved fibers of the round brush.

flat A common brush shape for modern styles of painting, in which the ferrule is flattened and the fibers are parallel.

fresco A method of painting onto wet plaster that predates oil painting and remained more popular than the use of oils in southern Europe during most of the Renaissance period. Technically more akin to watercolor than oil painting.

fugitive The description of a pigment that has been proven to fade or darken over time.

genre A familiar type of subject matter, such as still life, allegorical, or portraiture. "Genre painting" more specifically describes scenes that depict everyday life.

gesso Originally describing an absorbent glue-based ground for tempera and oils, this term now also refers to an acrylic substance with less absorbency and greater flexibility that is perhaps more useful to the oil painter.

glaze A transparent application of paint over a light ground or underpainting that can provide rich and luminous coloring.

grisaille A picture painted in various grey values without color, often as a training exercise or as an underpainting.

ground A preliminary layer of paint placed over the size to create a smooth, strengthened surface of the right absorbency for receiving paint. Often colored for oil painting.

half tones The area across a depicted surface where the light mass and the shadow mass are indistinct from one another.

handling This term is used to describe the brushwork, or approach to form, belonging to a particular painter.

illusionism Synonymous with both the Italian Renaissance and the development of oil painting, illusionism is the attempt to create within a picture a believable space where the subject conforms to spatial rules common to the world of the viewer.

impasto A noticeably thick application of paint, often used for expressive effect.

Impressionism An art movement of the late nineteenth century, epitomized by the work of Monet and Pissarro, which emphasized color, light, and open brushwork, and heavily influenced successive modern movements.

imprimatura The term refers to the coloring of a white ground or a transparent underpainting upon a white ground.

key The aggregate tonal value of a picture, described as high key if it contains many pale tints and low key if it is mostly dark.

lay-in A simple underpainting indicating general colors and values, eschewing details and surface description, and intended to be overpainted.

lightfastness The ability of a paint to maintain its color over time. The opposite of fugitive.

local color The inherent color of an object regardless of reflected or ambient color variations that appear upon it.

mahl stick A stick with a rag attached to one end that provides support when a steady hand is needed for painting details or working on areas of wet paint.

matteness The degree to which the painted surface is glossy or dull. Matteness can be affected by many factors such as oil content, ground absorbency, or pigment type.

medium A general term describing the materials in which a work of art has been created, such as oils, fresco, marble, and so on, and more specifically the fluid that is used to mix paints into a brushable consistency.

modeling The ability to render three-dimensional form by careful deployment of tonal values across the surface of an object.

Modernism The collective name for the many movements across the artistic disciplines that flourished in the first half of the twentieth century. Broadly characterized by an emphasis on form above content, a simplification of visual language, and the pursuit of the new and original.

monochromatic Describing a picture painted in one hue alone; often used as a method of underpainting or sketching.

naturalism An accurate, objective, and unidealized approach to form depiction.

oiling out The process of applying medium or retouching varnish to a dull and lifeless picture prior to repainting.

optical mixing The effect of two or more colors, placed as unmixed dots or dabs next to each other, combining in the air between picture and eye.

palette An impermeable board of wood or glass used to arrange and mix paints. Also describes the choice of colors an artist uses for any given picture.

panel Traditionally describes a paint support made of solid wood, but is sometimes extended to include other manufactured types of board.

picture plane Denotes the surface of the picture, particularly in relation to illusionistic pictures that appear to lie behind this plane and some trompe l'oeil subjects that appear to project forward from it.

plein air The practice of painting outside, in front of the subject.

pointillism The use of dots as a form of notation across the picture surface. Pointillism is found specifically in the work of Seurat and more informally in impressionist styles.

pouncing Method of transferring a linear drawing onto a support by pushing charcoal dust through small pin pricks along its lines.

primary colors These are red, yellow, and blue. Primary colors cannot be mixed by combining other colors.

primer A primer is the paint mixture used to create the ground. The terms "priming" and "ground" are practically synonymous.

realism Used in a similar way to "naturalism" to describe believable and accurate representation, this term can also be used more metaphorically to mean a striving for truthful depiction of one's experiences.

Renaissance The artistic and intellectual revolution of the fifteenth and sixteenth centuries emanating from Italy and spreading to the north of Europe. The movement centered around the revival of classical ideals, the value placed on the artist as an individual, and the development of illusionism and naturalism.

resin The sticky secretion of trees that is used as the basis of traditional varnishes.

retouching varnish A weak and temporary varnish that can be applied sooner than the picture varnish to make the surface of a dry picture more glossy and receptive to paint.

round The traditional brush shape with fibers set into a round ferrule, tapering inward toward a point.

saturation Alternative term to describe the intensity or richness of a color. Can also relate practically to the amount of oil drawn into an absorbent ground or paint layer.

scumble An application of single or multiple brushstrokes, broken across the paint surface and only partially covering what is beneath.

secondary colors The three hues green, orange, and violet, which are produced by mixing two primary colors.

shade Technically used to describe a color mixture darker than its parent color, usually through the addition of black.

sinking Literally, the sinking of oil from the paint layer into the previous layers or ground, giving the surface a matte and lifeless appearance.

size A thin flexible layer to protect the support from the long-term corrosive effect of oil-based paints and grounds.

solvent Volatile compounds, such as turpentine or mineral spirits, that are used to dilute paints and resins, and to clean brushes and surfaces.

stain A general painting term describing the impregnation of an absorbent surface with an often transparent pigment, adding color without increasing the paint thickness.

stand oil A drying oil with similar properties to many resinous varnishes.

stretcher A wooden frame used to stretch a canvas for painting.

support The generic name for all materials and supporting devices, such as stretchers, used as a surface upon which to paint.

surface Alternative term for the support, more suitable perhaps as a description of the flat painting surface itself.

tempera The technique of painting using an emulsion (usually egg yolk) as the medium. Shares similarities and historical connections with oil painting, though it is much faster drying.

thinner A solvent used in the medium to dilute the paint, but which does not itself remain in the dried paint film.

tint A high-value version of a color often achieved with the addition of white.

tone An alternative to "value" as a description of the lightness or darkness of a color.

tooth The degree of texture across the paint surface that will encourage greater adhesion of paint and broken-color effects.

toptone The surface appearance of a solid undiluted color, sometimes referred to as its "home value."

trompe l'oeil Meaning literally "deceive the eye," this term refers to an advanced form of naturalism, often found in still life, whereby the painted subject appears to exist in real space, sometimes seeming to project forward from the picture's surface.

turning The area on a voluminous surface where the light mass "turns" into the shadow mass. This can be slight or broad depending on the form and light source.

underpainting A planned preliminary painted layer that will be partially or totally covered, when dry, by subsequent layers.

undertone The translucent appearance of thinned paint when light is reflected through it off a light ground.

varnishes Resinous substances used to add properties to the painting medium and as a protection for the finished picture surface.

vehicle General name for a fluid that "transports" the pigment onto a surface.

The past masters

This list gives the full names, dates, and nationalities of the famous historic oil painters who were mentioned in the text.

Auerbach, Frank, 1931–, British
Braque, Georges, 1882–1963, French
Canaletto, Giovanni Antonio, 1697–1768, Italian
Caravaggio, Michelangelo Merisis da, 1571–1610, Italian
Cézanne, Paul, 1839–1906, French
Chardin, Jean-Baptiste-Siméon, 1699–1779, French
Constable, John, 1776–1837, British
Corregio, 1490–1534, Italian
Dalí, Salvador, 1904–89, Spanish
Daubigny, Charles–François, 1817–78, French
David, Jacques-Louis, 1748–1825, French
de Kooning, Willem, 1904–97, Dutch/American
Degas, Edgar, 1834–1917, French
Delacroix, Eugène, 1798–1863, French
Derain, André, 1880–1954, French
Dürer, Albrecht, 1471–1528, German
El Greco, 1541–1614, Cretan (of Spanish School)
Fantin-Latour, Henri, 1836–1904, French
Freud, Lucien, 1922–, British
Gauguin, Paul, 1848–1903, French
Géricault, Théodore, 1791–1824, French
Goya, Francisco de, 1746–1828, Spanish
Hals, Frans, 1582/3–1666, Dutch
Holbein, Hans, 1497/8–1543, German
Hopper, Edward, 1882–1967, American
Ingres, Jean-Auguste-Dominique, 1780–1867, French
Kahlo, Frida, 1907–54, Mexican
Kandinsky, Wassily, 1866–1944, Russian
Kiefer, Anselm, 1945–, German
Kline, Franz, 1910–62, American

Leonardo da Vinci, 1452–1519, Italian
Magritte, René, 1898–1967, Belgian
Manet, Edouard, 1832–83, French
Matisse, Henri, 1869–1954, French
Michelangelo Buonarroti, 1475–1564, Italian
Mondrian, Piet, 1872–1944, Dutch
Monet, Claude, 1840–1926, French
Moody, Victor Hume, 1896–1990, British
O'Keeffe, Georgia, 1887–1986, American
Picasso, Pablo, 1881–1973, Spanish
Pissarro, Camille, 1830–1903, French
Poussin, Nicolas, 1594–1665, French
Raphael, 1483–1520, Italian
Rembrandt, Harmensz van Rijn, 1606–69, Dutch
Renoir, Pierre-Auguste, 1841–1919, French
Rubens, Peter Paul, 1577–1640, Flemish
Sargent, John Singer, 1856–1925, American
Schiele, Egon, 1890–1918, Austrian
Schnabel, Julian, 1951–, American
Seurat, Georges, 1859–91, French
Spencer, Stanley, 1891–1959, British
Stubbs, George, 1724–1806, British
Titian, c. 1485–1576, Italian
Turner, Joseph Mallord William, 1775–1851, British
Van Dyck, Anthony, 1599–1641, Flemish
Van Eyck, Jan, c. 1384–1441, Dutch
van Gogh, Vincent, 1853–90, Dutch
Velázquez, Diego, 1599–1660, Spanish
Vermeer, Jan, 1632–75, Dutch
Verrochio, Andrea del, 1435–88, Italian

Index

Credits

The publishers would like to thank Kim Williams, for demonstrating alla prima techniques (pages 57–59) and Jeremy Duncan, for demonstrating broken color techniques (pages 65–67) and providing the sketchbook material on page 87 (all other demonstrations and sketchbook material by Brian Gorst). Many thanks to all the artists whose work has been reproduced in this book. Thanks also to the following contributors of materials and equipment, photographed throughout the book:

L. Cornelissen & Son Ltd
105 Great Russell St.
London
England WC1B 3RY
t.: +44 (0)20 7636 1045
f.: +44 (0)20 7636 3655
www.cornelissen.com

Daler-Rowney Limited
P.O. Box 10
Bracknell
Berkshire
England RG12 8ST
t.: +44 (0)1344 424621
f.: +44 (0)1344 4865111
www.daler-rowney.com

Lukas Künstlerfarben und
 Maltuchfabrik
Dr. Fr. Schoenfeld GmbH
Harffstr. 40
D-40591 Düsseldorf (Wersten)
Germany
T.: +49 (0)211 78130
F.: +49 (0)211 781324
www.lukas-online.com

H. Schminke & Co.
GmbH & Co. KG
Otto-Hahn-Str. 2
D-40699 Erkrath
Postfach 3242
D-40682 Ekrath
Germany
t.: +49 (0)211 2509 446
f.: +49 (0)211 2509 461
www.schmincke.de

Spectrum Oil Colours
272 Haydons Road
South Wimbledon
London SW19 8TT
t.: +44 (0)20 8542 4729
f.: +44 (0)20 8545 0575
www.spectrumoil.com

All photographs and illustrations are the copyright of Quarto Publishing plc. or of the artists who supplied images. Individual credits are given throughout the book next to the reproduction of each painting. While every effort has been made to credit contributors, we would like to apologize in advance if there have been any omissions or errors.